IMAGES
of America

BEECH MOUNTAIN

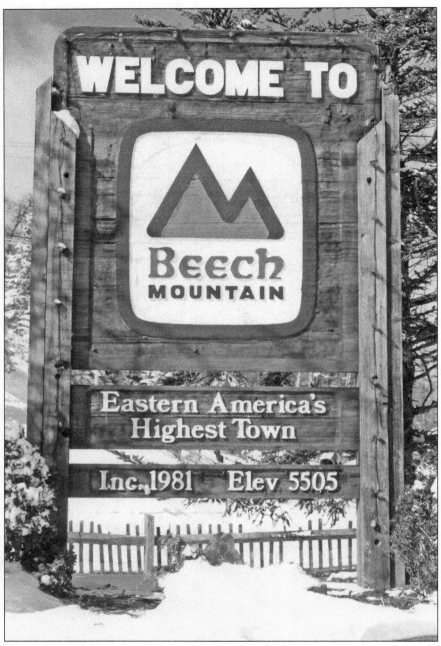

Welcome to Beech Mountain. The welcome sign tells the important facts about the town. Beech Mountain is eastern America's highest town at 5,505 feet, and it was incorporated in 1981. Seasonal plantings beautify the area year-round. (Photograph by Ralph Miller.)

On the Cover: Enjoying the spectacular view from the Beech Mountain ski slopes are (from left to right) Delores Robbins, Dr. Tom Brigham, and Rushton Hays. Brigham's dream of a ski resort in the South merged with Robbins's experience in development to produce the Beech Mountain Resort, "a place for all seasons." (Courtesy of Jim Brooks and Gary Townsend.)

IMAGES
of America

BEECH MOUNTAIN

The Beech Mountain Historical Society

ARCADIA
PUBLISHING

Copyright © 2009 by the Beech Mountain Historical Society
ISBN 978-1-5316-4466-6

Published by Arcadia Publishing
Charleston, South Carolina

Library of Congress Control Number: 2009926126

For all general information contact Arcadia Publishing at:
Telephone 843-853-2070
Fax 843-853-0044
E-mail sales@arcadiapublishing.com
For customer service and orders:
Toll-Free 1-888-313-2665

Visit us on the Internet at www.arcadiapublishing.com

We dedicate this book to Dr. Thomas H. Brigham and
Grover Cleveland Robbins Jr., who made it all happen.

CONTENTS

ACKNOWLEDGMENTS

The Beech Mountain Historical Society thanks the many members of our community who generously gave their time for interviews, answered our questions, and shared their photographs and memorabilia with us. We are also grateful to the Beech Mountain Town Council and Tourist Development Authority for financial support when we needed it most and to the Beech Mountain Club for its support of this project.

 This book would not have been written without the contributions of all of the members of the Beech Mountain Historical Society.

Editor—Ann Iles
Copy Editor—Jerry Shinn
Photography Editor—Ralph Miller
Introduction—Jerry Shinn
Chapter One—Anne Curran and Ann Iles
Chapter Two—Judy Hilsmier and Nancy Kennedy
Chapter Three—Charlotte Clinger and Scotty King
Chapter Four—Ann Iles and Becky Wheeler
Chapter Five—Marge Bailey, Dee Dee Berger, and Anne Shinn
Chapter Six—Marge Bailey, Hank Cooper, and Jack Dickerson
Chapter Seven—Connie Bowen and Barbara Piquet

INTRODUCTION

The ancient Greeks believed their highest mountain was home to their gods. Moses went up a mountain to confront his god and receive the Ten Commandments. The Jewish people made pilgrimages to the mountain where Jesus later took his disciples and looked down on Jerusalem and wept. American pioneers climbed the mountains to look west to the next frontier. John Muir's accounts of climbing in the Sierra Nevada Mountains have inspired generations of environmentalists. People climb mountains seeking inspiration and enlightenment, refreshment and recreation, and to explore the limits of physical and spiritual experience, from fear and exhilaration to comfort and serenity. Mountains are very special places.

Beech Mountain is even more special than most, which is why some people come here as tourists and really never leave, and why we have compiled this book to chronicle and celebrate its history.

It is special not only because it is a mile high and a place of awesome natural beauty in every season, of spectacular vistas and densely forested slopes broken by mighty compound fractures of jagged rock, gushing creeks, and waterfalls. It is special not only because the ridges and clouds bend sunlight at sunset to spread layers of indescribable color across the sky. It is special not only because of cool summer days and autumn colors, the screaming north wind that sculpts snow banks, and the sunshine sparkling on ice, or because the spring thaw uncovers some of the greenest grass on the planet and roadside borders of wildflowers. It is special not only because of deer and wild turkeys, bobcats and foxes, an occasional foraging bear, goldfinches, cardinals, and hummingbirds. And not only because it is a place to escape the heat of flatland summers and the rush and stress of urban and suburban life to rest, hike, ski, swim, fish, or play tennis or golf.

It is special for all those reasons, but also because of the influence and legacy of creative people who envisioned a community respectful of the environment, and of their successors who rescued, preserved, and enhanced the vision. You will see and read about them and their struggles and accomplishments in the pages that follow.

It is special most of all because, for some of us, it is home.

HIGH, SERENE, HAPPENING

a High Place
where air and water
are clear and clean and cool
and the whispered prayers of trees
are heard.
 Beech

a Serene Place
where a Man and a Woman
and their Children discover
that Living is Laughing Love and
playing in the clouds.
 Beech

a Happening Place
as is no other
where flying on skis
or on horseback
or on wings
or watching a golf ball climb
across the rooftop of the world
can be a daily thing.
 Beech

an Away Place
away from cities
and flashing lights
and one-way streets
and shrouds of smoke
and crashing sounds
and crushing pressures.
 Beech

an Irreplaceable Place
because the world's land
is being torn, scarred, devoured
and in the multiplying Manrace
there is no Mercy for the wildflower
and fern and brook and virgin vistas.
But here, 9,000 promises are made,
a promise to every acre and
to all Living Things upon it.
 Beech

an Impossible Dream
a Preposterous Promise
an Indisputable Fact.
High.
Serene.
Happening.
Away.
Irreplaceable.
Forever.
 Beech Mountain.

—Kays Gary
Carolina Caribbean Corporation
c. 1967

One

THE MOUNTAIN

The birth of the Appalachian range occurred some 300 million years ago in a series of crustal plate collisions that produced peaks originally as high as 35,000 feet. The first nomadic hunter-gatherers wandered into the southern Appalachians at least 12,000 years ago. Beech Mountain was a favorite hunting ground of the Cherokees, probably the largest of the tribes, and they called it "Klonteska," meaning pheasant. An early phase of westward expansion in the late 18th and early 19th centuries occurred with the migration of European-descended settlers, many from the British Isles, into the Blue Ridge. The Great Trading Path, originally an animal trail that the Native Americans used, originated in Virginia, stretched across the Carolinas to Georgia, and crossed Beech Mountain.

The American Civil War in these mountains was not fought by great armies, but by small groups of men skirmishing against enemies who were also their neighbors, relatives, and former friends. At the Battle of Beech Mountain, Union soldiers opened fire on the Confederates and drove them from the field. No memorials commemorate the battle, and only a few men were involved, but the animosity lasted for generations.

In 1877, some 2,000 stills were operating in the region. Before Prohibition, most moonshine was sold locally, but after 1916, when North Carolina outlawed beverage alcohol, moonshining became big business.

In 1900, Edgar Tufts founded Lees-McRae College in Banner Elk, which continues to be important in the lives of Beech Mountain residents. Tufts organized 5-mile hikes to the top of Beech for his students.

From 1926 to 1940, the Beech Haven Camp for Girls, near the base of the mountain, offered a wide range of outdoor activities. The camp closed due to a devastating flood, and it is now the Irmolot Lodge.

The mountain has a rich, fascinating history, and we hope you will enjoy reading these pages and looking at these pictures, learning and perhaps reliving some of the highlights of that story.

Here's to Beech!

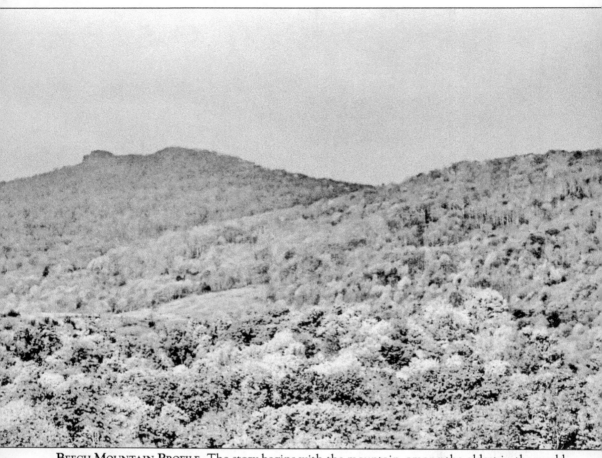

BEECH MOUNTAIN PROFILE. The story begins with the mountain, among the oldest in the world and one of the highest and largest in the Blue Ridge of the southern Appalachians. The mile-high mountain covers parts of two North Carolina counties, includes two communities, and to the north stretches almost into Tennessee. Like much of the Blue Ridge, Beech Mountain remains cloaked in deep, dense forest, both deciduous and evergreen, despite logging and the commercial and residential development that created the Beech Mountain town and resort. More than 100 inches of snow fall here every winter, and summers are cool with daytime temperatures rarely climbing above the 70s. This photograph shows the north face and pinnacle rock outcropping. (Photograph by Don Mullaney.)

OLD GRISTMILL. The Harmon family was one of the early families to settle near Beech Mountain. In the 1840s, Wiley Harmon built this mill, which served several surrounding communities. The mill stood near Laurel Creek, not far from the present Beech Mountain Club golf course. (Courtesy of Cecil Tester.)

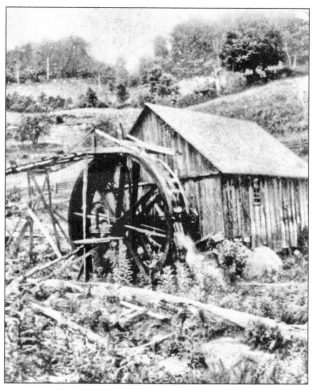

HARMON FAMILY SAWMILL. Lumbering was an important industry in the early days on Beech Mountain. Joel Wayne (J. W.) Harmon owned and operated this sawmill in the early 20th century and moved it periodically to be near available timber. Harmon purchased hundreds of acres of timberland, and during the Great Depression he experienced his most profitable sales of timber, mostly to a Johnson City, Tennessee, lumberyard. (Courtesy of Cecil Tester.)

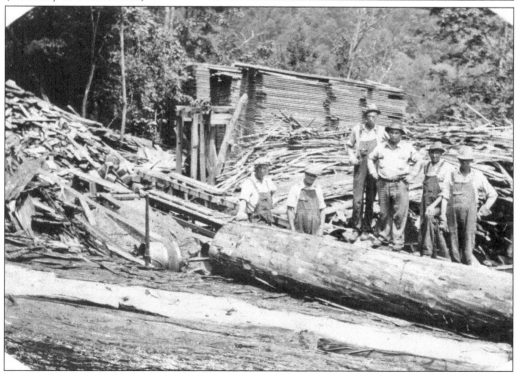

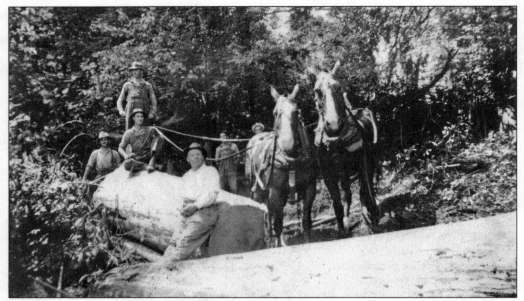

DRAGGING A LOG TO THE MILL. Shown here are J. W. Harmon (in the front) and his crew dragging a huge log to the mill. Although Harmon employs a good-looking team of horses in this picture, oxen were more commonly used because they were stronger, steadier on uneven terrain, and less costly to maintain. (Courtesy of Cecil Tester.)

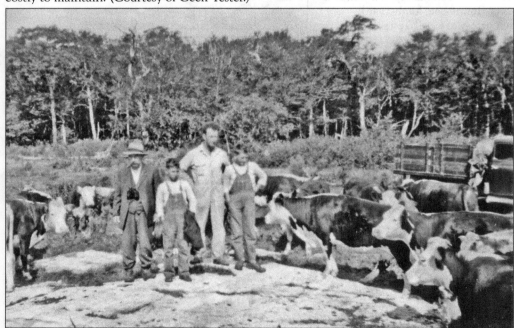

BEECH MOUNTAIN MEADOWS. J. W. Harmon (left), Malcolm "Mack" Tester, and Mack's sons, Larry and Lester, look over livestock at the Beech Meadows in the 1940s. During summers in the late 1920s and early 1930s, Harmon and his family drove their cattle to the mountaintop to graze on the tender "love grass." The family lived in covered wagons, enjoying the cool weather, with some tending the cattle while others cut timber and sawed the logs. (Courtesy of Cecil Tester.)

TESTER FAMILY ON PINNACLE ROCK. Henry Hedgie Tester and three of his children, (from left to right) Joel Callaway, Elizabeth Carolyn, and Cecil Fred (grandchildren of J. W. Harmon), perch on the South Pinnacle Rock at the top of Beech Mountain. Behind them are the Elk River Valley and the mountains beyond. The Pinnacles of Beech later became a popular destination for hikers, campers, and photographers. (Courtesy of Cecil Tester.)

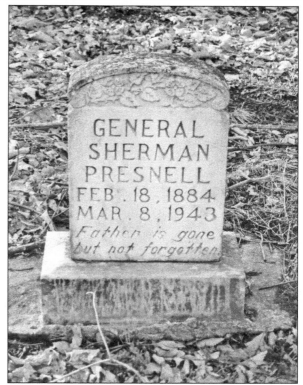

PRESNELL FAMILY CEMETERY. Near the 18th tee of the Beech Mountain golf course, the cemetery includes several darkened stones with no engravings. Visible dates show it was in use from the 19th through the mid-20th centuries. The most prominent stone is that of General Sherman Presnell, 1884–1943. General was his name, not his rank, indicating that his parents were Union sympathizers during the Civil War. (Photograph by Ralph Miller.)

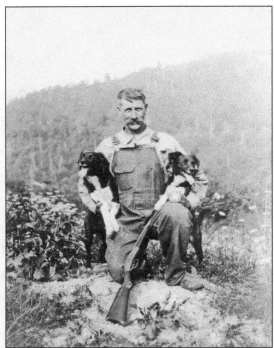

GENERAL PRESNELL AND BEAR DOGS. Presnell's son Loyd noted on the back of this photograph that his father had helped kill a large, fat bear weighing about 400 pounds on the south slope of the mountain. Bear, deer, squirrels, and other game were plentiful on Beech before development. (Photograph by Loyd Presnell; courtesy of Hazel Presnell Baker.)

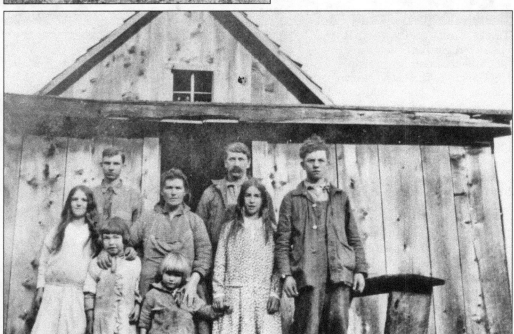

FIRST HOME OF PRESNELL FAMILY. General Sherman and Hattie Presnell (center) pose in front of their first home with several of their children and grandchildren. Loyd, the photographer, seldom appears in family pictures. He was likely the only person on Beech to own a camera at the time (1930s). The house was near present-day St. Andrews Road and the 18th tee. (Photograph by Loyd Presnell; courtesy of Hazel Presnell Baker.)

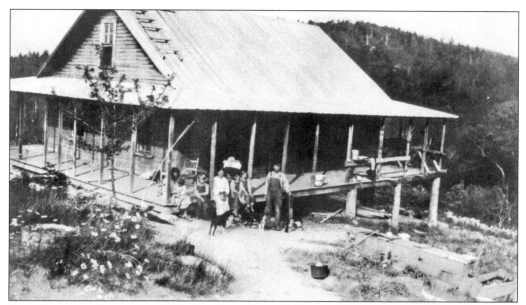

FOUR PRESNELL GENERATIONS. Martha Eggers Presnell, her son General Sherman, his wife, Hattie, their daughter-in-law Ida, and several of Loyd and Ida's children stand in front of the family's second home around 1935. Water was piped from a spring to a spring box for keeping food cold. The house was moved in the 1950s. Hoover Presnell, Loyd's son, still lives there. (Photograph by Loyd Presnell; courtesy of Hazel Presnell Baker.)

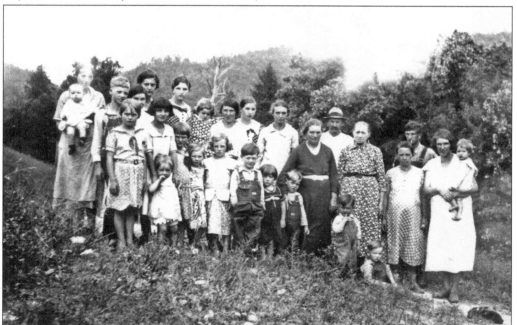

THE LOYD PRESNELL FAMILY. This photograph, taken in the late 1930s, shows Loyd Presnell's extended family: brothers and sisters, their wives, husbands, children, and grandchildren. Loyd liked to get the family together for pictures, and especially liked to include a field of wildflowers, as seen here. (Photograph by Loyd Presnell; courtesy of Hazel Presnell Baker.)

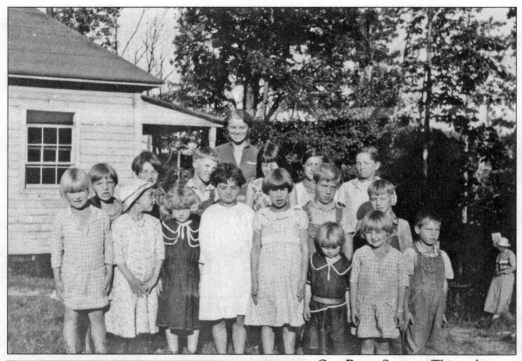

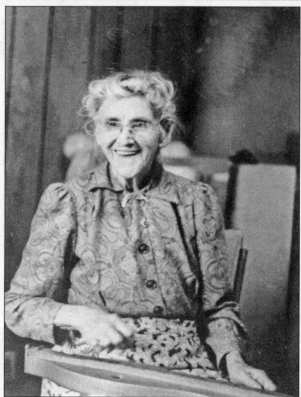

ONE-ROOM SCHOOL. This is the Beech Creek School, the teacher, Susan Henson, and her pupils as they looked around 1934. The school had grades one through seven. Susan Henson was originally a Banner, from the prominent family for whom Banner Elk was named. Sometimes the school had to close from Christmas to April because of the weather. (Courtesy of Hazel Presnell Baker.)

BUNA PRESNELL HICKS. Buna Hicks is shown with her dulcimer. She was quite a musician and played the dulcimer, fiddle, and other instruments. She had a musical family of 10 children, and they all made and played several instruments and sang together. On Sunday afternoons, when the family sat on the front porch of their store and sang, many people came to listen. (Courtesy of Hazel Presnell Baker.)

LEES-MCRAE MOUNTAIN DAY.
Rev. Edgar Tufts, founder of
Lees-McRae College, began
the tradition of Mountain Day,
when the entire school made the
5-mile climb up Beech Mountain.
Waiting at the Meadows was
the wagon pulled by Maude and
Mac, the school's horses, with a
sumptuous lunch. The Pinnacles
of Beech was a favorite spot for
photographs of this event, such as
this one taken in 1937. (Courtesy
of Lees-McRae College Archives.)

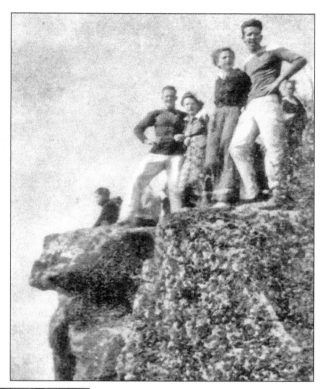

A STONE FOR A PULPIT. In 1912, Smith
Rominger came upon an unusual stone
while logging on Beech Mountain.
He approached Reverend Tufts about
using it for the pulpit of the church
Tufts was building in Banner Elk. A
team of oxen pulled the boulder on
a specially made logging sled for 8
miles over a rough road. The stone
pulpit still graces the front of the
Banner Elk Presbyterian Church.
(Photograph by Ralph Miller.)

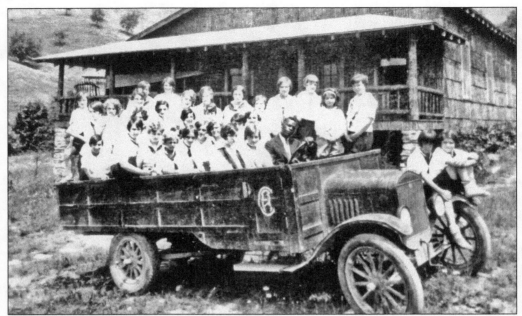

BEECH HAVEN CAMP FOR GIRLS. Campers in their uniforms appear ready for an outing as they sit in the camp's truck in 1929. The camp, near the foot of Beech Mountain at an elevation of 4,000 feet, was in operation from 1926 to 1940. Campers enjoyed swimming in the lake, horseback riding, tennis, expressive dance, and other traditional camp activities. (Courtesy of the Stirling Collection, Carson Library, Lees-McRae College.)

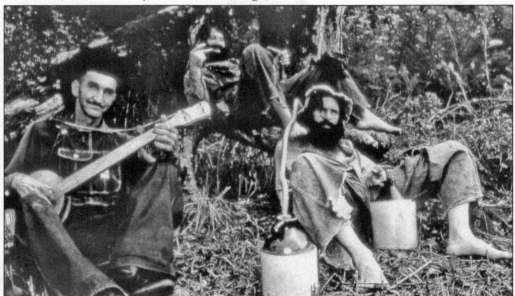

MODERN DAY MOONSHINERS. Though these men look like the real thing, they actually posed for this picture with equipment they found when they were putting in the road up Beech Mountain in the 1960s. Many stills were in operation on the mountain from the time of the earliest settlers. Hard cider was made from apples, and white lightning was manufactured from grain. (Courtesy of Fred Pfohl.)

18

Two

DREAM AND DISCOVERY

On Beech Mountain, Tom Brigham, a Birmingham dentist, has long been credited as the father of southern skiing. An avid skier and founder of the Birmingham Ski Club, Dr. Brigham longed for the skiing of his youth in Vermont. Soon after he learned of snowmaking in the northeast, he was on the road scouting southern mountain ranges. For three years, he pored over topographical maps and studied the southern Appalachian winter weather. He discovered some existing small ski areas, but his goal was a large ski resort.

During the summer of 1960, Dr. Brigham made a trip to Linville, North Carolina, to see his friend Chessie MacRae. MacRae was a fellow Birmingham resident whose family summered in North Carolina and owned a portion of nearby Sugar Mountain. Dr. Brigham was eager to explore. He eventually selected Beech Mountain for his project and convinced some Birmingham friends, including George and Chessie MacRae, to join him in pursuit of his dream on the wilderness peak 1-mile high. The group began to buy options on land at the top of Beech, but they encountered a holdout in W. T. Elder, a major property owner. Elder's land included a 7.5-acre tract at the summit that ski lift manufacturers considered essential to the proposed development. The tract was also valuable because of its magnificent 360-degree view. After lengthy correspondence and discussion, Elder granted the Birmingham investors a first right of refusal to purchase the critical land.

By the early 1960s, Brigham had designed a plan for the Beech Mountain ski slopes, but construction had barely begun when investors' finances ran short. Brothers Grover and Harry Robbins were busy nearby developing Hound Ears Resort, which offered skiing. Brigham pressed the Robbins brothers until Grover actually visited Beech, where he could share Brigham's vision of a major ski resort. He agreed to take on the project. Original investors were paid 50¢ on the dollar for land options. Brigham was hired as project supervisor, and Chessie MacRae remained on Beech Mountain to work in sales.

DR. THOMAS H. BRIGHAM. A native of Georgia, Brigham was raised in Vermont. Upon graduation from Tufts Dental School in Boston, he returned to the South to teach and practice dentistry. His efforts led to the development of Beech Mountain and Sugar Mountain in North Carolina and Snowshoe in West Virginia, which is why he is often referred to as the father of southern skiing. (Courtesy of Dr. Tom Brigham.)

THE UNDEVELOPED PEAK OF BEECH. The meadow in the foreground is Elderberry Ridge looking beyond what is now the Beech Mountain Parkway. When the Birmingham investors arrived, the state road, 16 feet wide, graveled, and treacherous, wound its way around 13 hairpin curves. It ended halfway up the mountain and narrowed to one lane, which continued to the meadow and the Elder farm on Elderberry Ridge. (Photograph by Dick Street.)

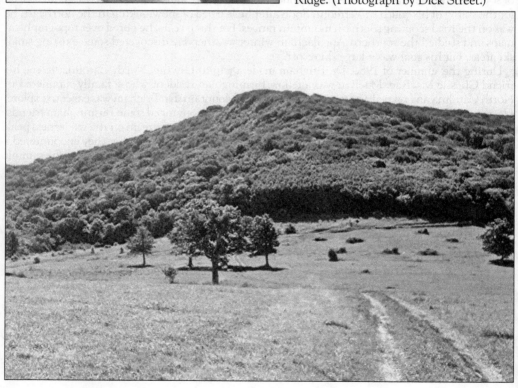

THE END OF THE ROAD. The Denton Gwaltney home, on a curve just above the current entrance to Grey Fox Ridge, is where the 16-foot-wide state road up the mountain ended. For many years, the Gwaltney family ran a dairy farm with a large barn and silo. Later a portion of the Gwaltney property was turned into a blueberry patch. (Photograph by Nancy Kennedy.)

THE MEADOW ON ELDERBERRY RIDGE. During summers in the 1950s and 1960s, the most populated spot on the mountain was the Meadows on Elderberry Ridge. Campers and photographers enjoyed the cool temperatures, challenging hikes, gorgeous vistas, and the two natural springs nearby. Earlier farmers from as far away as Lenoir herded cattle and sheep up the mountain to feed on the lush grasses. (Photograph by Dick Street.)

PEACE AND TRANQUILITY IN THE MEADOW. Campers and photographers who braved the trek up Beech Mountain by jeep, horseback, or on foot were rewarded with incomparable views such as this one. Here a weathered tree, bent by relentless mountain winds, frames the view of clouds hovering around the unmarred ridgeline of neighboring mountains. The gnarled limbs of the trees on the exposed summit of Beech Mountain, twisted and shaped by many years of harsh winds and weather, and the bright emerald green of the lush grasses around them later provided the inspiration for artist Jack Pentes when he envisioned the Land of Oz at the top of the mountain. (Photograph by Dick Street.)

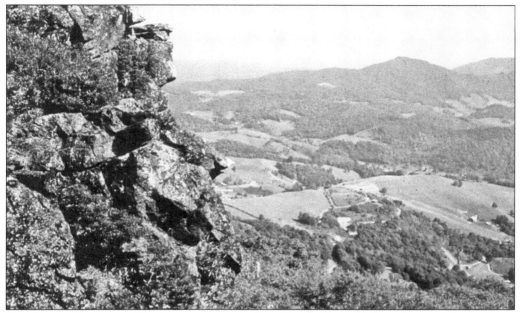

THE SOUTH PINNACLE. The long-range views from Beech Mountain's south pinnacle made it a popular hiking destination. The vista off Beech's south face overlooks the Gwaltney dairy farm (lower right), the town of Banner Elk (center), and the undeveloped Sugar Mountain ridgeline (upper right). Years later, visitors to the Land of Oz enjoyed the same view. The outcropping is easily identified on the ridgeline near the Land of Oz gazebo. (Photograph by Dick Street.)

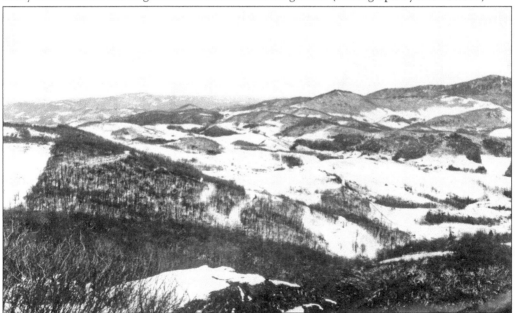

360-DEGREE VIEW. Tom Brigham knew he had found the location for a marketable ski resort when he saw the view from the mountain's north pinnacle. He also selected Beech for its average annual snowfall of over 100 inches. This vantage point, near the top of the current black and blue slopes, was part of the critical 7.5 acres owned by W. T. Elder. (Photograph by Dick Street.)

MARY AND W. T. ELDER. Mary Elder was descended from two of Banner Elk's founding families, the Voncannons and the Banners. In the 1950s, while farming in Belle Glade, Florida, W. T. Elder purchased large tracts of property on Beech Mountain, much of it being auctioned due to unpaid taxes. He asked Bob Guy of Avery County Bank to act on his behalf, thinking other potential buyers would not try to outbid the bank. (Courtesy of Mary Elder Frisbie.)

SERENA CHESTNUT "CHESSIE" MACRAE. She and her husband, George, introduced Dr. Brigham to the High Country and invested in his Beech Mountain project. To boost sales of private-issue stock, she sculpted a topographical map with dental materials from Brigham's office. The MacRae home on Skiway Circle provided access to the proposed slopes, where she was charged with monitoring temperature, snowfall, and other climatic conditions. (Courtesy of Kate MacRae.)

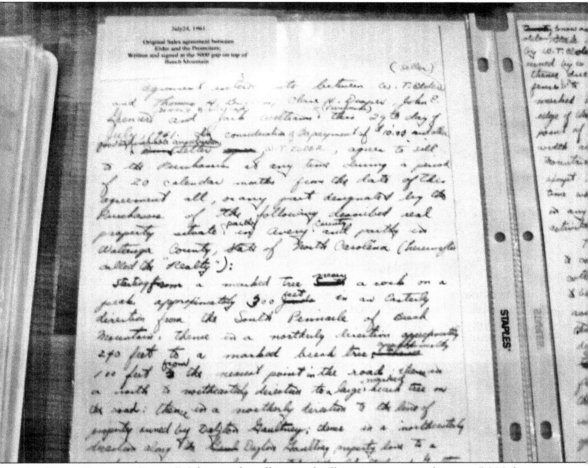

AN "AGREEMENT TO AGREE." After much walking and talking in a gap meadow at a 5,000-foot elevation, W. T. Elder finally agreed to give the Birmingham investors a first right of refusal to his precious 7.5-acre tract. According to Tom Brigham, it was late in the afternoon on July 29, 1961, when Boone attorney John Williams and Dr. Brigham sat on the tailgate of W. T. Elder's truck and handwrote the above agreement. A sign of a simpler time, the subject property was described in part as follows: "Starting from a marked tree near a rock on a peak approximately 300 feet in an easterly direction" The price was not to exceed $1,000 per acre. The document was signed by W. T. Elder, Thomas H. Brigham, Clare H. Draper, John E. Grenier, and Jack Williams. Joe F. Williams was a witness. After all the parties signed the contract, they shook hands and headed down the mountain. (Photograph by Nancy Kennedy.)

EARLY SKIING ON BEECH. Banner Elk native Dick Street tries out his new wooden skis in anticipation of the ski slopes being constructed on Beech Mountain. One of the best locations to practice was on this unpaved roadway, which became Beech Mountain Parkway. Street recalled that his first skiing venture was so challenging that it also became his last attempt at the sport. (Courtesy of Dick Street.)

CARRYING ON THE DREAM. From left to right, Tom Brigham, Rushton Hays, and Delores Robbins pause as they ski down a mountain road. When the Birmingham investors' funds ran short, Brigham appealed to Grover, Harry, and Spencer Robbins, who had developed Tweetsie Railroad, a theme park, and Hound Ears, a gated golf course community. The Robbins brothers formed Appalachian Developments, Incorporated, and enlisted Brigham to help complete the project. (Courtesy of Gary Townsend.)

Three

A Place for All Seasons

Carolina Caribbean Corporation (1966–1975), while short-lived, left a legacy of which the original 40 or so investors and the Robbins family could be proud. Beech Mountain, its flagship development, came out of bankruptcy with the Beech Mountain Club intact and the mountain changed forever. The other properties have fared well and prospered over time so that thousands of people have enjoyed the amenities built by Carolina Caribbean Corporation. It was an exhilarating, bumpy ride, one that many of those involved with the corporation remember fondly. Those with homes on Beech Mountain, bought or built before 1975, remember well the dizzying excitement that Beech represented. It is difficult to explain just how unique the experience was, but those interviewed used terms like "wild, wild west" and "exciting." Property owners mingled with the rich and famous in the Beech Tree Inn and on the ski slopes. Professional ski races and live entertainment enhanced the experience. The stores in Beech Tree Village were abuzz with activity, and the Land of Oz brought in thousands of tourists. The Beech Tree Inn provided an ambience unseen before or since in the mountains of North Carolina. Some bought lots on Beech just so they could belong to the club. The Red Baron Room members were proud of their affiliation to the point that they would proudly wear the Blue Max pendants to country club functions in their home cities. Always the visionary, Grover Robbins developed many properties, but he loved Beech Mountain. He asked that his ashes be sprinkled on the mountain and a gravestone placed at the pinnacle, which was done. In July 2006, a portion of Highway 184 leading up the mountain was dedicated to him. Each time those who love Beech Mountain travel up that highway, it is a reminder of Grover Robbins and the extraordinary corporation that developed this unique place called Beech Mountain—"a place for all seasons."

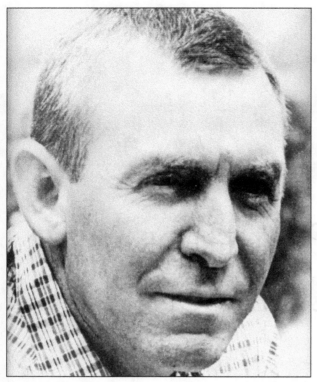

GROVER ROBBINS, THE VISIONARY.
Born into a successful business
family in Blowing Rock in October
1919, Grover and brothers Harry
and Spencer built the Hound
Ears Club in nearby Foscoe and
salvaged a historic rail line and
engine to create the Tweetsie
Railroad theme park near Boone.
Grover envisioned and formed
Carolina Caribbean Corporation,
perhaps the most ambitious
and volatile company ever seen
in western North Carolina.
(Courtesy of Spencer Robbins.)

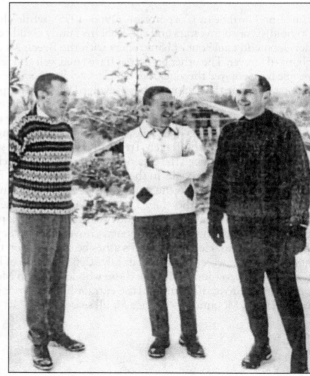

THE PROMOTERS AND DEVELOPERS.
Shown here are, from left to
right, brothers Grover and Harry
Robbins and Tom Brigham. They
merged their ideas for a ski area
and a year-round resort. (Courtesy
of the *Knoxville News Sentinel*.)

CAROLINA CARIBBEAN LOGO.
By 1965, Grover and Harry
Robbins had formed Appalachian
Developments, with 180 acres
on Beech Mountain. It quickly
expanded to 2,950 acres. The
next year the company acquired
property in St. Croix, Virgin
Islands, and changed the name to
Carolina Caribbean Corporation,
reflecting Grover's vision of
a unique year-round vacation
lifestyle, which he never saw
fulfilled. He died in March 1970.

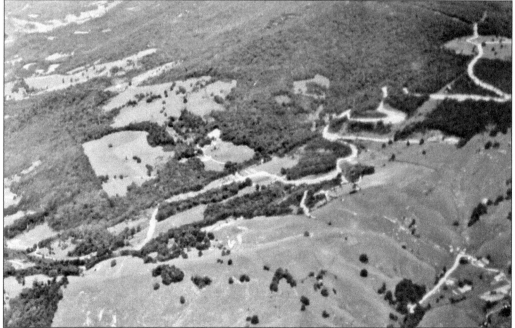

AERIAL VIEW OF THE PARKWAY. Taming the mountain was no small task. In 1967, building Beech
Mountain Parkway required blasting tons of rock with huge road graders moving boulders up the
steep mountainside. This 4-mile scenic road allowed the construction of the ski slopes, golf course,
alpine village, and other recreational facilities. In 2006, the road (Highway 184) was dedicated
as the Grover Robbins Jr. Highway. (Courtesy of Vernon Holland.)

29

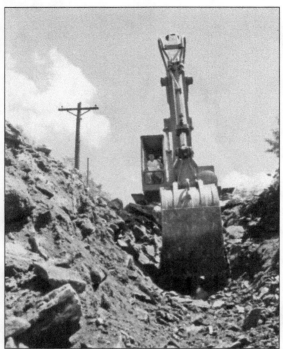

BLASTING OUT AN INFRASTRUCTURE. By the summer of 1969, twenty-nine miles of roads were graded and graveled. Even more difficult was digging 6 feet into rock to install water and sewer lines. More rock was excavated to create holding lakes for snowmaking. Meanwhile, engineers drafted a master layout, and utility hookups were in place. Amazingly Beech was ready for property sales by 1967, and the ski slopes opened that December. (Courtesy of Vernon Holland.)

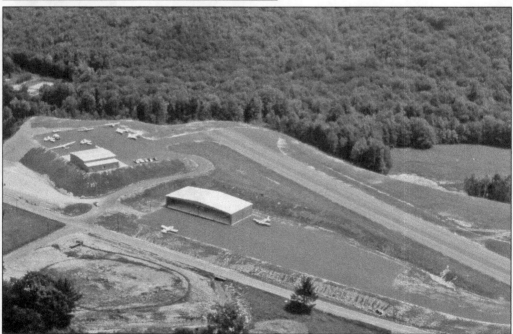

BEECH MOUNTAIN AIRPORT. At the foot of Beech, land was developed for the second of four planned golf courses and the Beech Mountain Airport. The completed 4,600-foot paved landing strip could accommodate DC-3s and Lear jets. The corporation, including Grover Robbins, an avid pilot, began flying in prospective buyers for fun-filled weekends and often-successful sales pitches. (Courtesy of Vernon Holland.)

LINVILLE LAND HARBORS. In 1968, Carolina Caribbean Corporation developed the 1,000-acre Land Harbors of America near Linville. A second Land Harbors opened in 1973 at Little River on the South Carolina coast. Carolina Shores was a $15 million joint venture with Blythe Properties of Charlotte. Another coastal property was for Windjammer Trailer Park. The company also acquired land for two residential tracts near Charlotte. (Courtesy of Jim Brooks.)

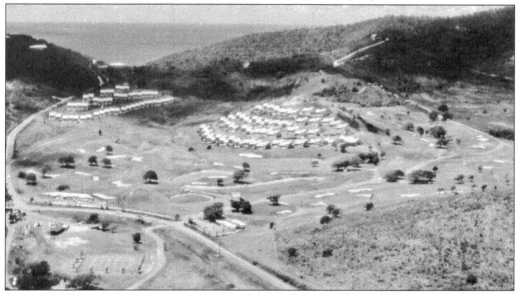

ST. CROIX RESORT. As a companion to Beech, Carolina Caribbean Corporation bought land for development on St. Croix, U.S. Virgin Islands, in the late 1960s, reportedly a $10 million investment. In September 1972, four tourists were machine-gunned to death at a St. Croix golf course. The incident frightened away potential buyers and devastated the island's economy. Facing continuing operating losses, the company sold the development to the property owners in May 1974 for $2.1 million. (Courtesy of Jim Brooks.)

STOCK PROSPECTUS. In February 1967, Carolina Caribbean Corporation made a public offering of 300,000 shares of common stock to help pay for the construction then underway. Meanwhile, Grover Robbins had persuaded the popular newspaper columnist Kays Gary to leave the *Charlotte Observer* and create marketing materials and news releases for Carolina Caribbean Corporation. Gary later returned to his first love, the newspaper, but not before his writing skills and contacts generated an explosion of publicity for Beech Mountain. The January 1967 *Southern Living* magazine cover featured a Hound Ears chalet with a story inside on the development of Beech Mountain. Articles about the new resort appeared in newspapers across the country. Skiing in the mountains of North Carolina was suddenly big news. Public sales meetings held across the country touted the opportunities for real estate investment and the resort lifestyles offered by Carolina Caribbean Corporation. With such marketing efforts, the national publicity, and an energetic sales force, sales of lots on Beech Mountain were soaring. With the boom in property sales, the stock offering was suspended after six months, in October 1967.

THE MILITARY CONNECTION. Retired special forces colonel Gordon M. Ripley came to Beech Mountain with his wife, Nell, following retirement. He joined the sales staff and contacted many retired military officers who later bought property. In April 1970, he became operations manager for Carolina Caribbean Corporation. The Ripleys moved into one of the first private residential chalets built on Beech. (Courtesy of Jim Brooks.)

A YOUTHFUL SALES STAFF. James N. "Jim" Brooks and other young men were drawn to Beech Mountain and joined the property sales staff of Carolina Caribbean Corporation many while still in college. Jim stayed and now owns a realty company at Beech. Many of these early sales representatives also stayed to become an integral part of Beech Mountain as it matured from the defunct corporation into a town. (Courtesy of Jim Brooks.)

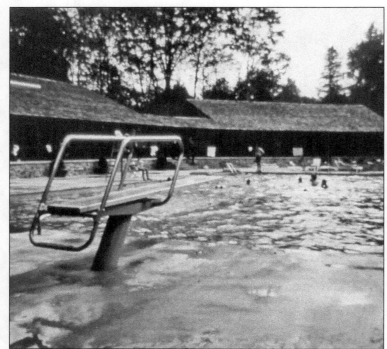

PLENTY OF RECREATION. By 1968, Beech Mountain offered many amenities. The junior-sized Olympic swimming pool featured a 15-foot diving well and a wading pool. A 2.5-acre fishing lake was nearby. Recreational facilities included a pool house, a shuffleboard court, and a summer day camp, the Youth Ranch, for ages 6 to 14. The Heidi Haus Nursery was staffed with trained personnel. (Courtesy of Vern Holland.)

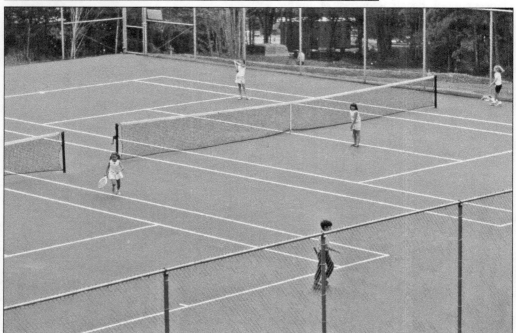

FROM TENNIS TO HORSEBACK RIDING. Up the hill from the pool were six grass-tex tennis courts, with two more under construction. Tennis lessons were available from the tennis professional, and supplies were sold in the tennis shop. The Beech Mountain Stables were located atop the mountain in High Meadows, an area that included a riding ring, horse rentals and boarding, private lessons, and trails. (Courtesy of Jim Brooks.)

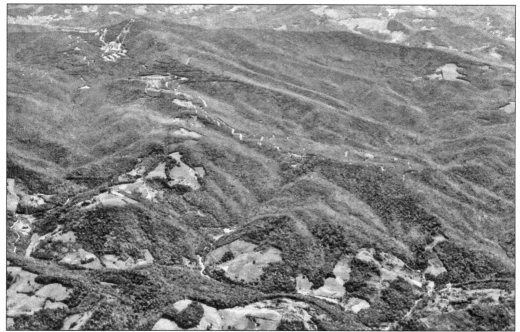

BUILDING THE GOLF COURSE. Grover Robbins, an avid golfer, hired Willard C. Byrd of Atlanta to design a championship layout, to be called Grassy Gap Golf Course, across challenging mountain contours and a steeply rising and falling landscape. The first nine holes were completed in 1969 and the final nine in 1971. At the time, it was the highest course east of the Mississippi. (Courtesy of Vern Holland.)

GOLF COURSE ADDITIONS. In 1973, a member clubhouse, including a dining room and a golf pro shop, was added at the Grassy Gap Golf Course along with maintenance buildings. Another course was planned near the Beech Mountain Airport, later the site of the Elk River Club. Still another course was planned for the West Bowl on Beech, but it never materialized due to the corporation's bankruptcy in 1975. (Courtesy of Vern Holland.)

EARLY HOME CONSTRUCTION. A second area called Charter Tract 2, later called Westridge, was opened for development in September 1967. On an appointed day, people wanting lots in this area were taken to a starting point and, as in a land rush of old, dashed down the rough-graded road and claimed their properties. Lots cost $2,500, and construction on homes there began in 1968. (Courtesy of Charlotte Clinger.)

ALPINE-STYLE CHALETS. Property sales on Beech exploded, and by the summer of 1969, more than 3,000 lots had been sold. Carolina Caribbean Corporation maintained architectural control over new home construction, and five chalet designs were approved. In keeping with the Alpine theme, the volkshaus, the alpenhaus, the kleinhaus, the skihaus (left), and the berghaus were offered. Round houses also were approved. (Courtesy of Jim Brooks.)

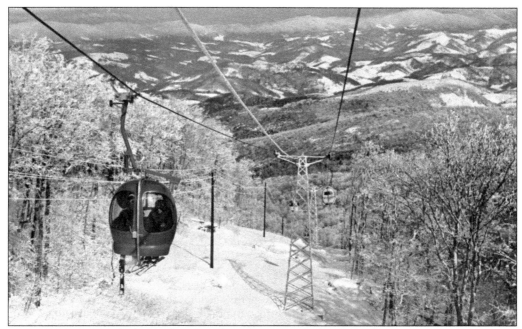

ON THE SLOPES. With the road up Beech Mountain completed, ski slope construction began in 1967 to open almost miraculously in time for the 1967–1968 seasons. The project included 5 miles of slopes, several trails, an area for the ski school, and the world's largest snowmaking operation. For the opening season, the Italian-built skis-on gondola could carry 1,000 skiers per hour to the top of Beech. (Courtesy of Jim Brooks.)

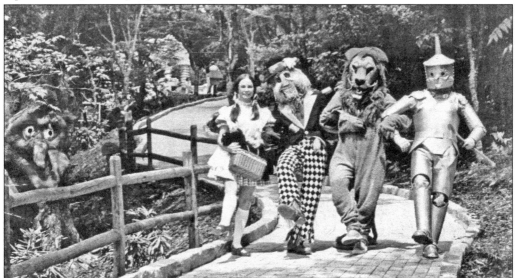

THE LAND OF OZ. To fill a gap in summer tourism, Grover Robbins turned to Jack Pentes, a Charlotte designer, to create a theme park. Pentes envisioned the Land of Oz, based on L. Frank Baum's book, the *Wizard of Oz*, and the movie starring Judy Garland. It opened in June 1970—three months after Robbins died—and became the No. 1 tourist attraction in North Carolina. (Courtesy of Jim Brooks.)

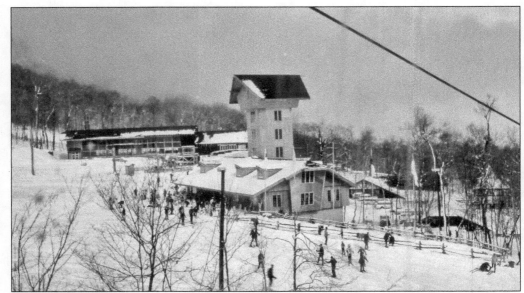

BUILDING THE VILLAGE. A bit of Bavaria was Robbins's idea for the village at the base of the ski slopes. He hired Claus Moberg, a Florida architect, to design this quaint pedestrian village. One of the first sites completed was the Carolina Caribbean Corporation sales office. The ski shops and rentals usually drew long lines. But the members' favorite spot was their clubhouse, the Beech Tree Inn. (Courtesy of Fred Pfohl.)

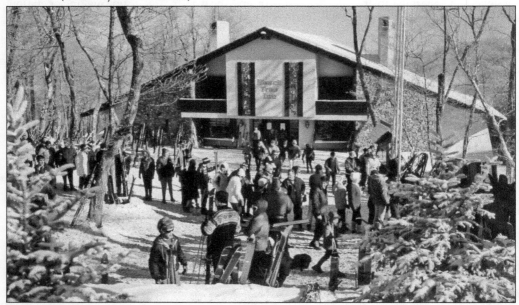

THE BEECH TREE INN. Grover Robbins built the members' clubhouse in the village, not at the golf course. It housed a year-round full-service restaurant with space for special events and entertainment. For example, during the fall of 1969, membership chairman William Pickelsimer planned an Oktoberfest, a Halloween party, a harvest ball, and a Beechkommer party. Tickets were $6 and included dining and dancing. The clubhouse was so successful that an expansion was planned. (Courtesy of Vern Holland.)

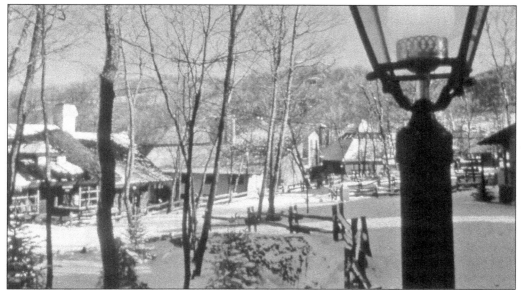

THE VILLAGE SPARKLED. The Beech Tree Village was the hub of activity on the mountain, both in winter and summer. In winter, snow and ice turned the village into a glittering wonderland, and night skiing and ice-skating made the evenings lively. In summer, the ice rink was turned into an activity center. The shops in the heart of the village were open year-round. (Courtesy of Jim Brooks.)

TEMPTATIONS FOR EVERY TASTE. In the village, you could watch fudge being made and pizzas being tossed in the air. You could order fresh bread and pastries to pick up later, enjoy delicatessen and cheese samples, and pick up supplies at the carpeted 7-Eleven. There were several clothing and gift boutiques, sports shops, and a home decor and design center. (Courtesy of Jim Brooks.)

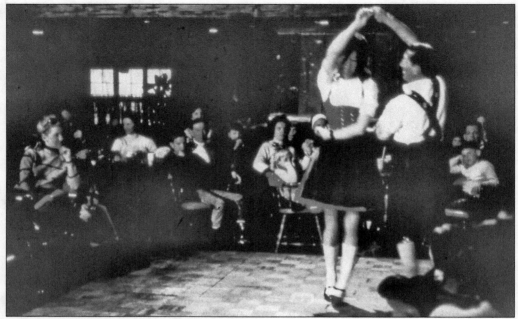

NEVER A DULL MOMENT. During the evenings of ski season, members were treated to the Austrian ski school instructors wearing Lederhosen, dancing, and singing with the oompah band. Members could pour their own liquor from a brown bag, which was legal, or buy a drink at the bar, which was not. In March 1973, the Watauga County sheriff raided the clubhouse and confiscated $10,000 worth of liquor and beer. (Courtesy of Vern Holland.)

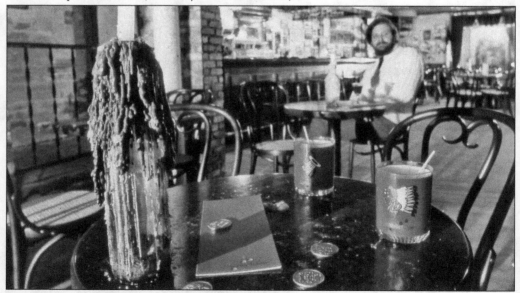

THE RED BARON ROOM. A private club, the Red Baron Room, opened in the basement of the Beech Tree Inn in January 1970. For $100 per year, members enjoyed authentically decorated rooms depicting World War I flying memorabilia and dedicated to German flying ace Baron von Richthofen, known as the Red Baron. The four rooms featured a museum, a bar, an operations room, and a supply room for card games. (Courtesy of Vernon Holland.)

RED BARON AWARDS. Vernon "Vern" Holland was an early Red Baron, meaning the recipient of an award given to leading Carolina Caribbean Corporation salesmen. Members, on the other hand, were awarded and proudly displayed their Blue Max pendants, given to those who collected coins for ordering such potent drinks as the Lafayette Escadrille, Night Patrol, Gotcha, Kicking Mule, Sopwith Camel, and Hat in the Ring. (Courtesy of Vern Holland.)

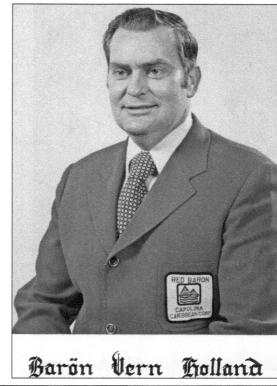

Barön Vern Holland

THE BAR AT THE RED BARON. The main room featured an authentically designed and detailed 1917 French bar replete with wine racks. This large bar was a favorite with members as well as the Carolina Caribbean Corporation sales staff. Many a land sale was completed there. The piano player provided entertaining music, and members enjoyed dancing all over this lower level. The Beech Tree Inn was now complete. (Courtesy of Vern Holland.)

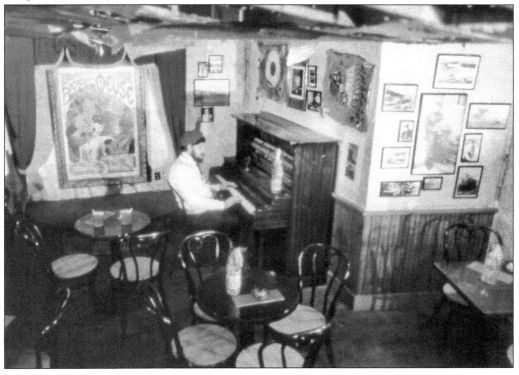

BOOM OR BUST IN THE BALANCE. While members frolicked on the slopes and in the clubhouse, Carolina Caribbean Corporation executives were worried. Although Beech was booming, operating costs at St. Croix were a huge drain on the corporation's resources. In the summer of 1974, Roger A. Hard (left) took over as president, vowing to save the company that had lost over $9 million by the fiscal year 1974. (Courtesy of Roger Hard.)

CAROLINA CARIBBEAN BANKRUPTCY. On February 28, 1975, the corporation filed for Chapter 10 bankruptcy reorganization. As early as 1972, Harry Robbins had secured loans to cover construction and operating costs. Beech was providing 80 percent of the income of Carolina Caribbean Corporation. Gasoline shortages and the economic downturn in 1974 made matters even worse. It was North Carolina's largest bankruptcy and dragged on until 1981. (Courtesy of Roger Hard.)

FILED
CHARLOTTE, N. C.
1:45 Pm
FEB 28 1975

U.S. DISTRICT COURT
W. DIST. OF N. C.

IN THE DISTRICT COURT OF THE UNITED STATES

FOR THE WESTERN DISTRICT OF NORTH CAROLINA
Asheville
~~CHARLOTTE~~ DIVISION

IN THE MATTER OF)
)
CAROLINA CARIBBEAN CORPORATION)
)
a corporation,)
)
Debtor)

In the Proceedings for the Reorganization
of a Corporation
A-B-75-723
No. ~~C-B-74-284~~

ORDER

This cause coming on to be heard upon the peitition of Carolina Caribbean Corporation, a corporation, the above named Debtor, verified February 28, 1975, and heretofore filed herein; and the Court having considered and examined the said Petition; the Court FINDS:

That the Debtor is a corporation and has had a substantial portion of its principal assets in Avery County in the State of North Carolina, within this District, for more than six months prior to the filing of the petition herein; that Debtor is unable to meet its debts as they mature; that adequate relief cannot be obtained under Chapter XI of the Bankruptcy Act; that it is reasonable to expect that a Plan of Reorganization may be effected in these proceedings; that said petition complies with Chapter X of the Bankruptcy Act and that it sets out facts showing need for relief, ~~and that it has been filed in good faith.~~

IT IS ORDERED:

1. That said petition be, and it is hereby, approved as properly filed under Chapter X of the Acts of Congress relating to bankruptcy.

Four

THE SLOPES

The history of skiing on Beech Mountain, like the sport itself, has many ups and downs. Long before Tom Brigham, the father of southern skiing, brought resort skiing to Beech Mountain, a few skiers were already using the slopes without the benefit of lifts or other amenities. According to Randy Johnson in his book *Southern Snow,* a Lees-McRae industrial arts instructor showed his students how to make skis in the school's shop in the 1930s, and the students headed to Beech Mountain. A Depression-era guide to North Carolina shows skiers on the Meadows of Beech.

The Brigham-Robbins development of Beech Mountain made the slopes more attractive and accessible for many thousands more skiers. According to Brigham, on opening day in 1967, the mountain was covered with rime ice and spectacularly beautiful but very cold, with a temperature of two degrees. Opening-day operational problems included running out of food and of rental boots in some sizes. A boy fell off the lift, and another boy got lost on a lumber road. But almost everyone had a blast.

As Carolina Caribbean Corporation began to fail, activity at the ski slopes declined. Tri-South Mortgage Company purchased the slopes and the Land of Oz, and retired Col. Norman "Norm" Smith, himself a skier, persuaded Tri-South that the ski resort and the theme park could be profitable. He became manager of both and was largely responsible for the first Beech renaissance. Smith improved the ski operation, promoted the mountain, and increased the number of skiers every winter.

In 1982, with Beech again at a low point, the Swiss wonder worker Sepp Gmuender entered the scene as general manager. He revamped the slopes and lifts, put in the Oz Run, and under the ownership of Ray Costin, who bought Ski Beech in 1985, installed a high-speed detachable quad lift, Beech's new claim to fame. Ray Costin's son, John, and later Wayne Hoilman, ran the operation from 1987 to 2001, when John Costin and his two sons, Ryan and Jack, took over operations. The Costins improved grooming and snowmaking in their first year and have plans for more improvements, including renovation of the village.

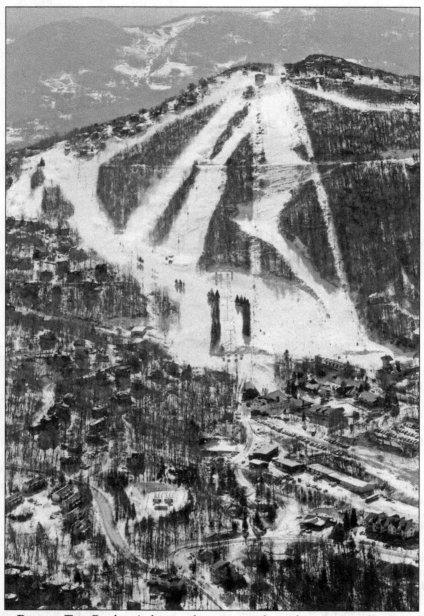

SKI BEECH RESORT. Tom Brigham's dream of a major southern ski resort is still very much alive, despite the problems that brought down Carolina Caribbean Corporation. The Beech Mountain resort and community are still thriving. Every year, thousands of skiers flock to Ski Beech, the highest ski resort east of the Mississippi. At the peak it is 5,505 feet above sea level. The slopes have a vertical drop of 830 feet. Skiers enjoy the spacious and varied runs, magnificent views, and the Beech Tree Village with an outdoor skating rink, shops, restaurants, and a ski school. The resort boasts 10 lifts, 15 slopes, 2 terrain parks, a tubing run, 90 skiable acres, and up-to-date snowmaking capacity. Ski Beech is augmented by excellent restaurants, shops, and galleries on the mountain and in nearby Banner Elk and Linville. (Photograph by Frederica Georgia; courtesy of Ken Ketchie.)

UP WITH THE GONDOLA. Carolina Caribbean Corporation lost no time in building the village, the ski slopes, and installing the lifts, as this active site shows. (Courtesy of Bill and Dee Hilt.)

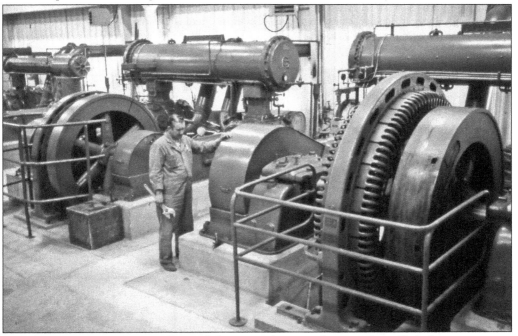

THE ORIGINAL COMPRESSORS. State of the art at the time they were installed, the compressors are still bright and shiny in this picture. Though most skiers never see or even think about the compressors, they are an essential element in making snow. (Courtesy of Jim Brooks.)

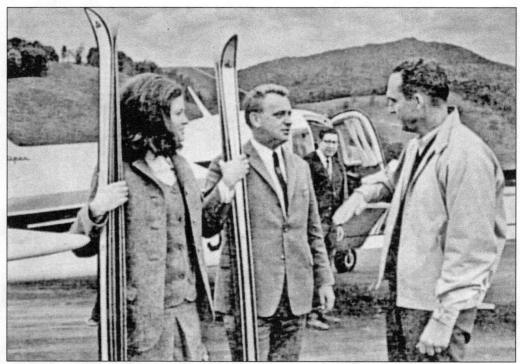

WELCOME TO BEECH. Austrian downhill racing champion and Beech's first ski school director, Willi Falger with his wife, Kitty, arrive at the newly constructed Carolina Caribbean Corporation airport at the base of Beech Mountain in 1967. Greeting them is Bill Arnett, Carolina Caribbean Corporation general manager. Chief pilot Bob Fielden looks on. (Courtesy of Gil Adams.)

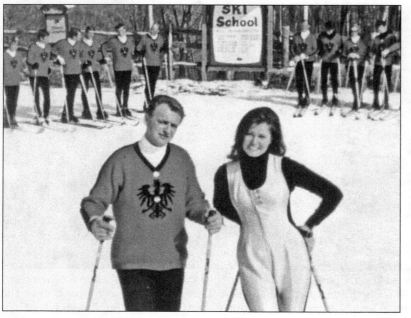

AUSTRIAN SKI INSTRUCTORS. Willi and Kitty Falger pose with the Austrian ski instructors in 1967. Anne Cone of Cone Mills, located in Greensboro, North Carolina, provided the sweaters with the crest of the Austrian eagle. Note the white gloves that were part of the uniform. (Courtesy of Bill and Nancy Kennedy.)

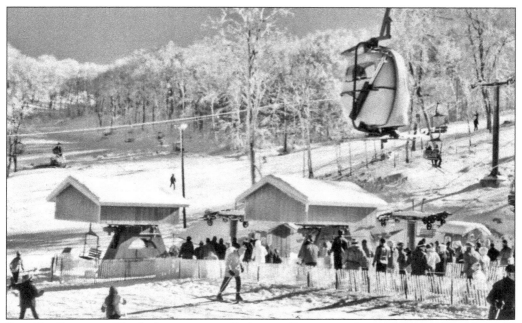

SKIS-ON GONDOLA. The Italian company Carlevario-Savio manufactured the gondola, the pride of Ski Beech. It was one of only three in the United States, the others being at Stowe and Squaw Valley. The gondola held two skiers on skis; the poles were in the outside quiver. At the top of the mountain, the front of the gondola opened to allow riders to ski out. (Courtesy of Bill and Dee Hilt.)

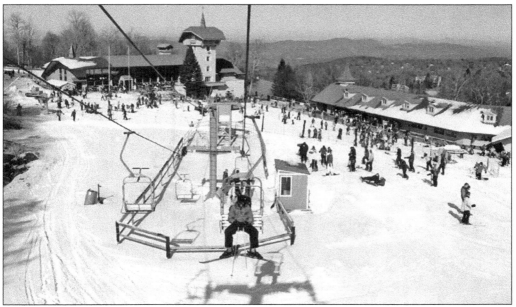

NUMBER SIX SKI LIFT. Goforth Manufacturers made this lift and all of the others, except for the gondola. Because it was once painted blue, Number Six was called the Blue Max. The other lifts also had nicknames, including the Purple People Mover, the Green Bean, the Green Apple, the Orange Blossom Special, and the Brown Bunny. (Photograph by Ken Ketchie.)

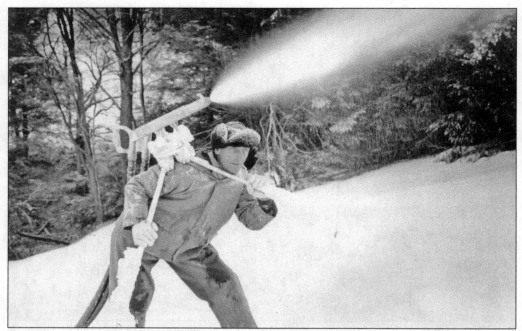

SPREADING THE SNOW. Southern skiing could not have developed without snowmaking technology. A slope attendant pulls this Larchmont toward the slopes. It was the first type of snow gun used at Beech. (Courtesy of Jim Brooks.)

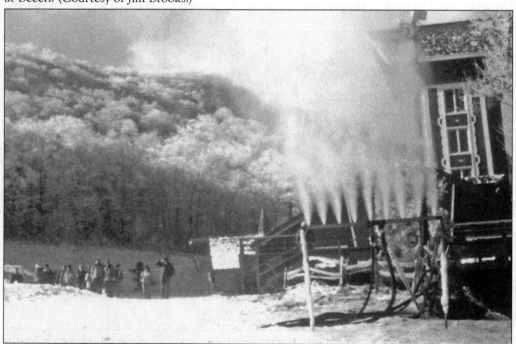

ANOTHER SNOW GUN. Snow guns come in many sizes and shapes. This is one of the early types, designed and made by Bob Ash. Snow guns use water and compressed air to make snow. (Photograph by Ken Lumsden.)

A LARGE SNOW GUN. This large, round aperture Hedco gun demonstrates another style in snowmaking. From the looks of all the snow around, it seems to have completed its job for the moment. (Photograph by Ken Ketchie.)

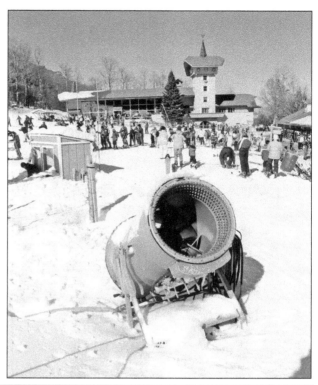

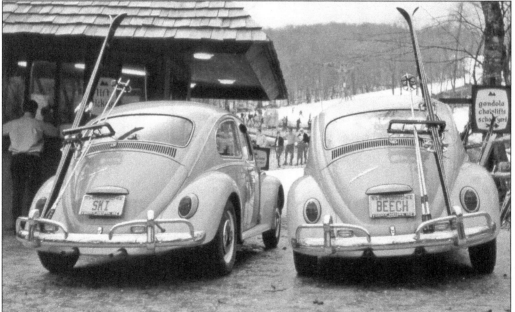

CLASSIC VOLKSWAGENS WITH SKIS. Volkswagens, because the motor was located in the rear, were popular with skiers in the early days at Beech Mountain. These cars could almost always make it up the steep road to the resort. These two Volkswagens were owned by none other than Tom Brigham and Grover Robbins. (Photograph by Ralph Gwaltney; courtesy of Fred Pfohl.)

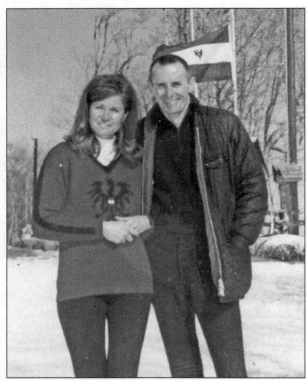

FIRST SKI PATROL CHIEF. Shown with Kitty Falger, Clyde "Slim" Owen, a Texan, moved to the area as a department head at Appalachian State University. He organized the first ski patrol at Beech Mountain when Tom Brigham lured him from Hound Ears. Beginning with 12 patrollers recruited from Appalachian Ski Mountain and Hound Ears, the ski patrol grew to over 100 members. (Courtesy of Slim Owen.)

VETERAN SKI PATROLLER. Gil Adams has been in the ski patrol since he was 18 years old. He and his brother, Mark, were the youngest to join in the early days. Gil Adams was involved in the only known ski patrol delivery of a baby, who arrived in the backseat of a stranded vehicle. Adams took over as head of the Beech Mountain Ski Patrol in 1987. (Photograph by Ken Ketchie.)

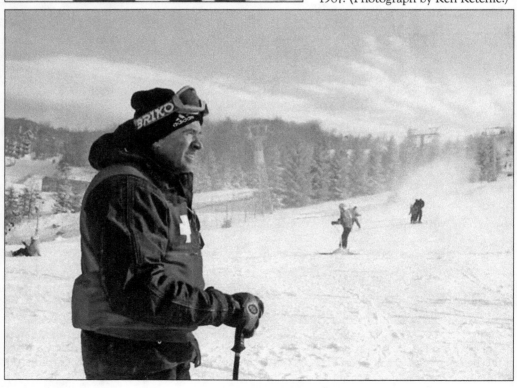

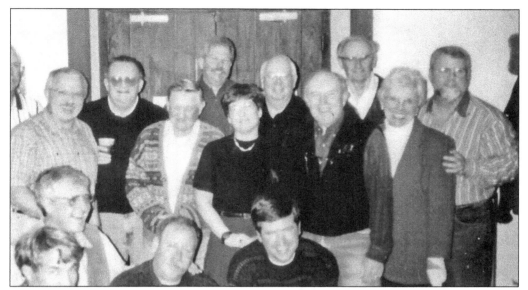

SKI PATROL REUNION. A gathering of early ski patrol members took place in 2001. Pictured from left to right are (first row) Bill Hanner, John Lawrence, Mark Adams, and Gil Adams; (second row) Jim Eades, Rodney Farris, Kermit Lowry, Roy Smyth, Jim Gayle, Bev Sizemore, French Moore, Dr. Jim Bowden, Slim Owen, Mary Ann Moore, and Mike Ohlson. (Courtesy of Slim Owen.)

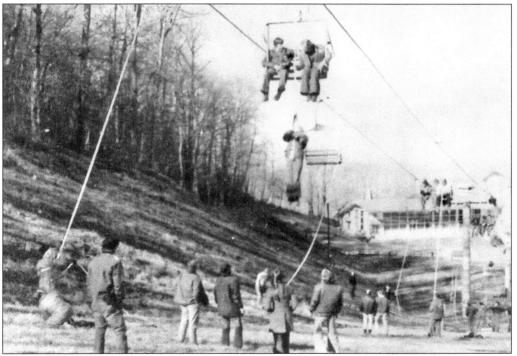

LIFT EVACUATION PRACTICE. Every year the ski patrol practices lift evacuation, a very difficult maneuver. Patrollers must be able to throw ropes over the lift and coax the skiers on the lift to slide a harness under their arms so that they can be let down. In many years, their practice becomes a reality. (Courtesy of Slim Owen.)

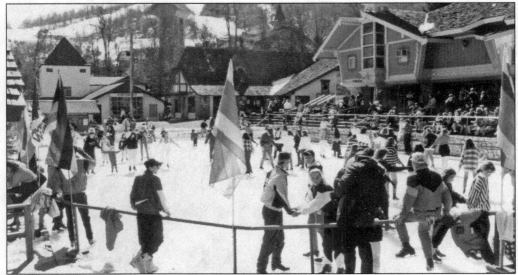

SKATERS ENJOYING THE ICE. The ice-skating rink was the center of village activity in the 1970s, with huge crowds participating in the five skating sessions held seven days a week. Often more than 300 people skated on one day. On Saturdays and Sundays, spectators could enjoy exciting professional shows. (Courtesy of Jimmy Durham.)

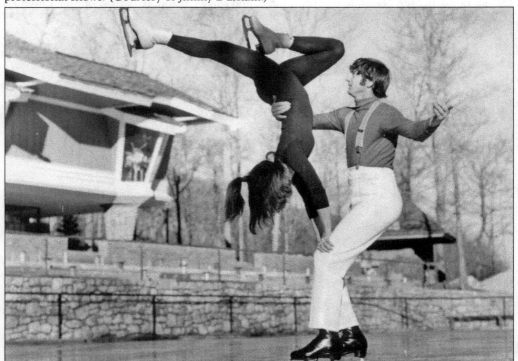

JIMMY AND MARGARET DURHAM. Carolina Caribbean Corporation hired Jimmy Durham as skating director in 1969. Durham, his wife, Margaret, and daughter, Tami, put on skating shows with guest professionals every weekend. Large crowds gathered to watch Durham jump through fire hoops and over barrels. (Courtesy of Jimmy Durham.)

CHRISTMAS ON THE ICE. Jimmy Durham and partner Jennifer Harris pose with a family after a holiday performance. Durham promoted the rink through his congenial personality and love of skating. With his brother Martin's help, he often brought skating professionals from Holiday On Ice to perform at Beech Mountain. (Courtesy of Jimmy Durham.)

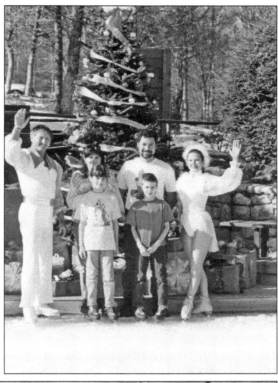

BEECH HOSTS PROFESSIONAL RACERS. The Snow Carnival of the South, 1969–1973, included the North Carolina Ski Cup. These International Ski Racers' Association Grand Prix races were the first professional ski races in the South. In 1973, Jean-Claude Killy won the Saturday giant slalom. Otto Tschudi won Sunday's slalom and was the overall weekend victor. From left to right are Spider Sabich, Otto Tschudi, Harold Steuffer, and Jean Claude Killy. (Courtesy of Jim Brooks.)

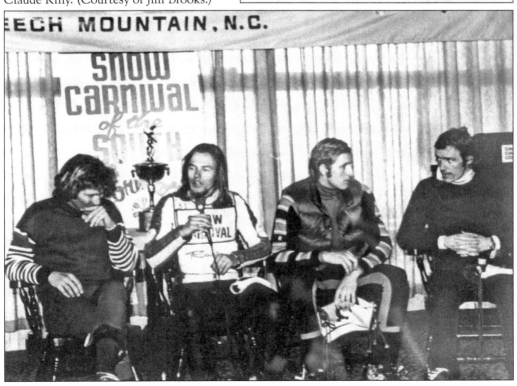

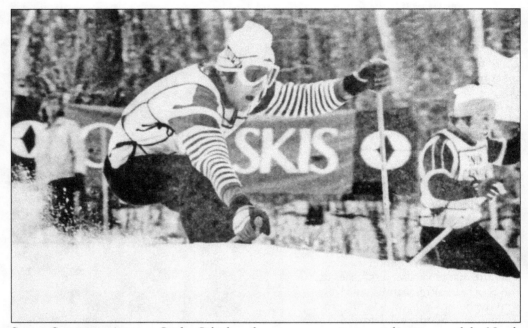

SPIDER SABICH IN ACTION. Spider Sabich, a frequent competitor, was the winner of the North Carolina Ski Cup race in 1972. The huge purses of $15,000 to $30,000 lured the pros and put North Carolina skiing on the pro-racing map. Women professionals came to the area when Beech provided a stop on the Women's Pro Ski Racing Tour in 1980. (Courtesy of B. K. Dorsey.)

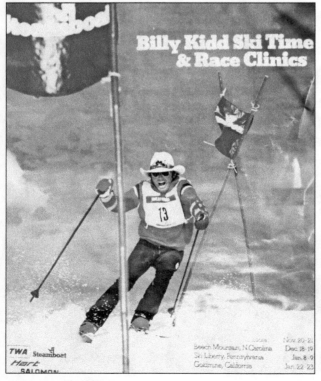

BILLY KIDD AT BEECH. Billy Kidd from Steamboat Springs raced at Beech Mountain in the 1970s. After one race, he declared that he had skied all over the world but had never been so cold. Kidd also held ski clinics at Beech and invited skiers to join him in skiing the mountain. (Courtesy of Jim Brooks.)

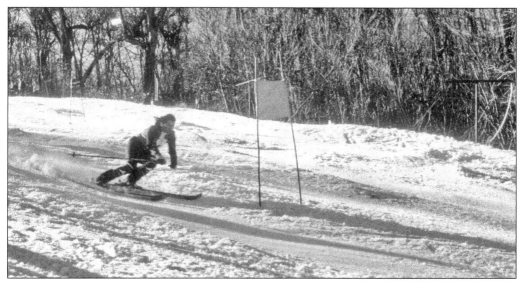

SKI CLUB RACING. A club racer shows perfect form as she competes on Beech Mountain. As president of Resort Management Incorporated, 1976–1979, Col. Norm Smith promoted ski club racing. He initiated the Southern Star Classic in 1978, 1979, and 1980, and recruited sponsors to offer $10,000, the largest prize ever offered to club racing teams. Winning clubs were the Charlotte Ski Bees, the Winston-Salem Ski Club, and the Southern Racing Consortium. (Photograph by Ken Lumsden.)

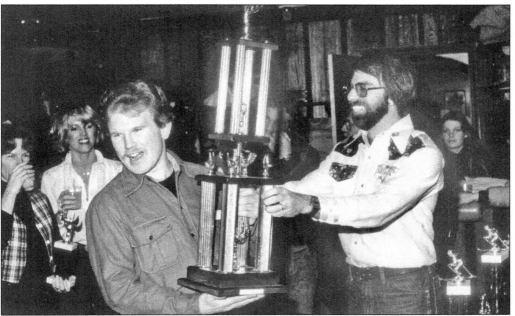

SOUTHERN STAR WINNERS. Ken Lumsden (left) and Steve Smith hold the huge Southern Star Classic trophy, won by the Winston-Salem Ski and Outing Club in 1979. With his wife, Marla, Smith founded the Crescent Racing Series as well as the racing team for the Winston-Salem Ski Club. Crescent Ski Council clubs have continued to race at Beech since 1970. (Courtesy of Ken Lumsden.)

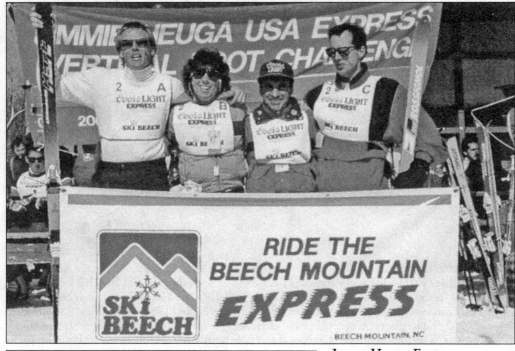

JIMMIE HEUGA EXPRESS WINNERS. Jimmie Heuga, an Olympic medalist diagnosed with multiple sclerosis (MS) at age 27, promoted exercise as an MS treatment and established the Jimmie Heuga Snow Express to raise money and spotlight the disease. Winning is based on vertical feet skied in a prescribed time by a team of three skiers. Beech sponsored these races for several years and sent several teams to national championships. (Courtesy of Paul Piquet.)

A VERY YOUNG CHAMPION. Jeremiah West began skiing on Beech Mountain at 22 months and started racing at five years of age. He won his age division in his first year. As a young skier, he also won seven National Standard Race (NASTAR) state titles and was the 1992 NASTAR national champion for 12 to 14 year olds. (Courtesy of Jeremiah West.)

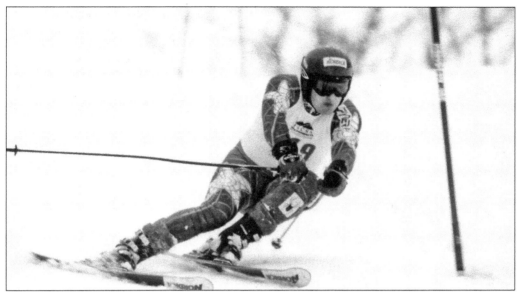

COLLEGIATE CHAMPION. After his strong beginning at Beech Mountain, West attended Killington and Stratton Mountain Ski academies and trained in Argentina. He won several Vermont state championships, the Rolex Junior Olympic title, and the Argentine Junior national title. He was ranked No. 1 in the world for 15 year olds in 1995 in the International Ski Federation (FIS) rankings for giant slalom, and he was an All-American at Lees-McRae College. (Courtesy of Jeremiah West.)

BEECH MOUNTAIN MANAGERS. Col. Norm Smith (left) and Bob Ash worked together to resurrect skiing at Beech after the Carolina Caribbean Corporation bankruptcy. Smith upgraded the compressors and electrical systems, and purchased new groomers. He promoted skiing as well as the Beech Mountain resort with a movie, *Discover Winter*, which he showed at southern ski clubs. He was the first to make Beech skiing profitable. (Courtesy of Col. Norm Smith.)

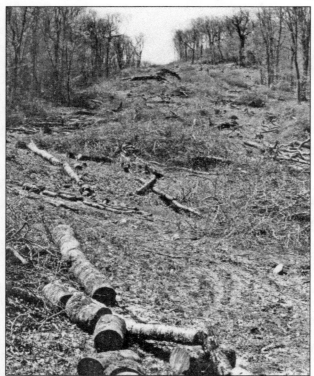

ADDING NEW SLOPES. Bob Ash designed two new slopes for Beech Mountain. Pictured here is Tri-South, now called Robbins Run. Smith and Ash also cut Southern Star, originally intended as a slope for racers, and added a new lift. Smith and Ash installed French drains on all the slopes as well as larger water lines for snowmaking. (Courtesy of Col. Norm Smith.)

SCHUSSING THE SLOPES. Colonel Smith and Ash enjoy the skiing on Tri-South, noted for its trees and bumps. Ash was well known for the revolutionary snow guns he invented. He and Smith made sure that the mountain was well covered with snow. Ash later became vice president of Beech Mountain Resort, Incorporated, from 1980 to 1983. (Courtesy of Col. Norm Smith.)

DIRECTOR OF SKIING. Tom Chesney, shown here with his freestyle partner, Kathy Andrews, wore many hats at Beech, including race director, NASTAR pacesetter, and director of skiing under Colonel Smith and Bob Ash. He was the featured skier in *Winter Song*, an award-winning ski film commissioned by Smith and Ash and produced and directed by Larry Gebhardt. (Courtesy of Bill and Dee Hilt.)

BALLET ON THE SLOPES. Gina Bradshaw Farfour and Mike Simmon demonstrate ski ballet on the slopes of Beech Mountain. In 1978, Chesney formed the Beechnuts, a team of local kids and experienced skiers who performed freestyle and ski ballet. Chesney coached the team and, with the help of ski instructor Kathy Andrews, created a popular show. (Courtesy of Gina Farfour.)

WHO NEEDS SNOW? Under the direction of Bob Ash and Tom Chesney, grass skiing became a popular summer activity at Beech in the late 1970s and early 1980s. Grass skiers could rent grass skis, take lessons, and participate in the race program. The sport eventually moved into national and international competition. In this picture, Leslie Bailey Metcalf looks ready for a run down the mountain. (Courtesy of Marge Bailey.)

SWISS EXPERTISE REVITALIZES BEECH. Sepp Gmuender of Appenzell, Switzerland, (center) enjoys the scene with his wife, Becky, and Dr. French Moore. Gmuender came to Beech in 1982 as executive vice president, vowing to have the ski resort running like a Swiss watch. He planted trees, improved drainage, built Lake Santis for additional water capacity for snowmaking, and brought in an Austrian chef and Swiss entertainers. (Courtesy of Marge Bailey.)

THE QUAD GOES IN.
Gmuender's greatest improvement was the installation of a Doppelmayr high-speed detachable quad lift in 1987. The quad was immediately popular with skiers because of the ease of loading and unloading and the quick ride to the top. Gmuender updated the other lifts and put in the Oz slope and lift on the back of the mountain. (Photograph by Ralph Miller.)

FOUR HAPPY SKIERS. The Beech Tree Inn and lift line are rapidly left behind as these skiers zip up the mountain. The high-speed quad replaced the old double lift, called the Orange Blossom Special. Like its predecessor, the skis-on gondola, the detachable, high-speed quad put Ski Beech on the map of southern ski resorts. (Photograph by Ken Ketchie.)

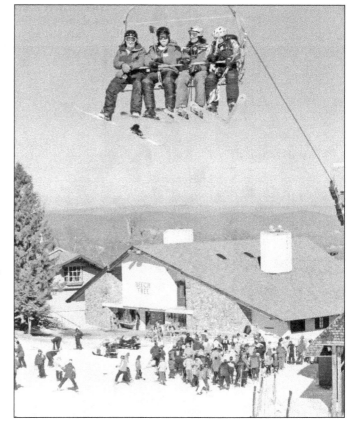

WINTERFEST CELEBRATION. Gmuender's assistant and marketing director, Paul Bousquet, developed a mid-winter carnival, Winterfest, for winter visitors and the entire community. Spanning two weekends, Winterfest hosted over 40 events, including the popular bathing beauty contest. Pictured here, an unidentified bathing beauty is encouraged by Paul Bousquet, a contestant in the men's division. (Courtesy of Jim Brooks.)

BABY, IT'S COLD OUTSIDE. Local mortgage banker Bill Hagna shows off his skiing form in the men's division of the beauty contest. Other Winterfest events included snow volleyball, broom hockey, dart tournaments, ski races, professional ice-skating exhibitions, and a Green Beret Para-Ski Exhibition. (Courtesy of Marge Bailey.)

THE GREAT CARDBOARD BOX DERBY. Drawing entries from as far away as Jacksonville, Florida, and Florence, South Carolina, the Cardboard Box Derby was perhaps the most popular event of Winterfest. Entries were judged for beauty, originality, and speed, with cash prizes awarded in each category. Beech Boogie, looking like an old-fashioned sleigh, was a strong contender in the contest. (Courtesy of Marge Bailey.)

A MUSICAL ENTRY. This cardboard piano demonstrates both beauty and originality. Note the candlestick, waiting to be placed upright for the judging. Was Liberace the driver? These fancy cardboard sleds had no steering or brakes. The crowds loved to see the ski patrol struggle with a huge orange snow fence, stretched across the finish line, in an attempt to stop the fast-moving contraptions. (Courtesy of Marge Bailey.)

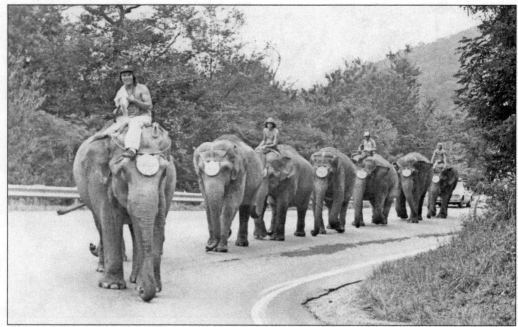

CIRCUS ELEPHANTS CLIMB THE MOUNTAIN. Never has there been more excitement on Beech Mountain than when the Clyde Beatty Cole Brothers Circus arrived in early September 1984. Paul Bousquet arranged for this very special appearance. Instead of trying to haul the elephants up the steep grade, which would have been risky, riders marched them all the way up the Beech Mountain Parkway. (Photograph by Paul Bousquet.)

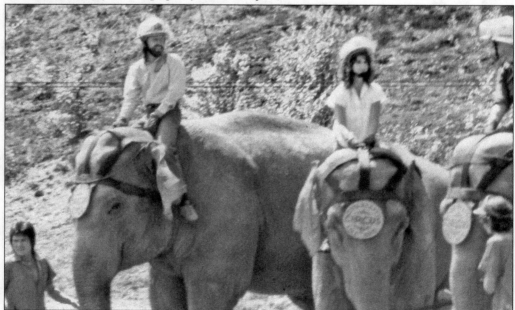

HOW ABOUT AN ELEPHANT RIDE? Some circus fans had the thrill of a lifetime riding the elephants. The circus stayed for five days, much longer than the usual one-or-two-night stands, so the circus folks and the Beech Mountain locals got to enjoy each other. (Courtesy of Jim Brooks.)

FOLK LIFE FESTIVAL HEADLINERS. Pictured from left to right are Miller Shropshire, Doc McConnell, and Rosa and Ray Hicks. Hicks, a 6-foot-8-inch storyteller, lived his entire life (1922–2003) on Beech Mountain and was the creator of the Jack tales. Shropshire, a Ski Beech employee, met him when the Smithsonian honored Hicks with a lifetime achievement award. That inspired her to stage an Appalachian Folk Life Festival on the mountain in July 1986. (Photograph by Paul Bousquet.)

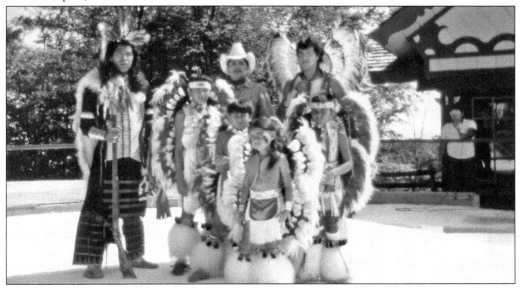

CHEROKEE INDIAN DANCERS. Recognizing the significance of the Cherokees to Beech Mountain, Shropshire went to the town of Cherokee and met Louise Bigmeat Maney, who helped her locate these Cherokee tribesmen. They showcased their traditions for an entire day of the folk life festival. The festival ended on Sunday with preaching by a real circuit rider. (Photograph by Paul Bousquet.)

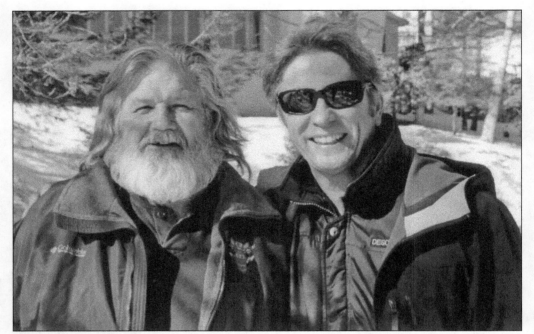

NEW MANAGEMENT. Wayne Hoilman (left) and John Costin ushered in a new era on the slopes. Costin was general manager from 1987 to 1996. He made Hoilman manager in 1997. Hoilman first worked there as a teenager checking lift tickets. He once denied a man access to the lift because he did not have a ticket. The man was Tom Brigham, who was so impressed with young Hoilman's conscientious performance that he gave him a raise. (Photograph by Ken Ketchie.)

SKI SCHOOL DIRECTOR. The first racing director was Scott Boutilier, who had been on the pro racing tour. Hired in 1978, he started and coached the Beech Mountain junior racing team and coached the Appalachian State University ski racing team. Boutilier became ski director in 1991 and established the Beech Mountain Ski Education Foundation for professional ski instructors. (Photograph by Becky Wheeler.)

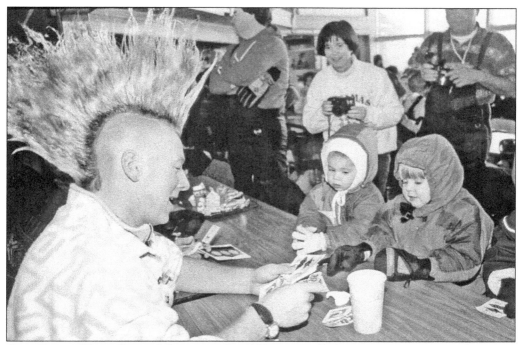

GLEN PLAKE VISITS BEECH MOUNTAIN. In 1993, nationally known extreme skier Glen Plake visited Beech, sporting his trademark Mohawk as he cruised down the slopes. It was one of those rare days when the mountain was above the clouds, which looked like a sea below. Plake raved about the view and then helped the ski patrol with a lift evacuation. He is shown here playing cards with some young admirers in the View Haus. (Photograph by Randy Johnson.)

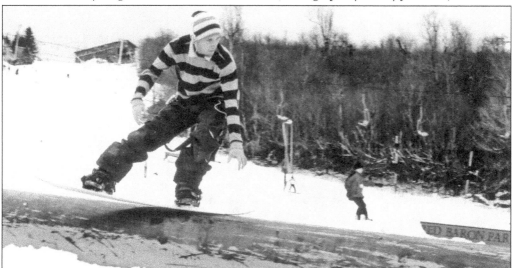

SNOWBOARDERS ENTER THE SKI SCENE. Snowboarding at first had minimal acceptance at ski resorts, but by 1998, it was an Olympic sport. Here a boarder at Beech rides a rail. Ski Beech put in its first half-pipe and quasi-terrain park in 1993. Brothers Ryan and Jack Costin developed a more challenging area with rails, boxes, and jumps for the 2008–2009 season, when Ski Beech held its first major snowboard competition. (Courtesy of Ryan Costin.)

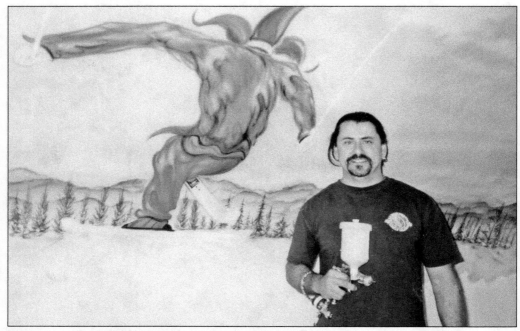

ART IN THE TUNNEL. The Viewhouse Restaurant, built in 1967, has a tunnel that is now a work of art. The Costins commissioned the work by Ramon Zavalza (above), who created a mountain scene of snowboarders, skiers, and tubers with his airbrush. Zavalza, self-taught, has worked with many accomplished artists during his 30-year career. He works from Universal Studios in Orlando. (Photograph by Becky Wheeler.)

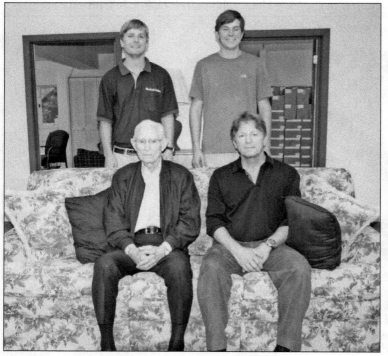

THREE GENERATIONS. Ski Beech began yet another renaissance when the Costin family took over management 2008. Pictured from left to right are (first row) Ray Costin and his son John; (second row) John's sons, Jack and Ryan. The Costins improved snowmaking with new technology and bought two new Piston Bully groomers. Plans include updating the Beech Tree Village. (Photograph by Ralph Miller.)

Five

THE WONDERFUL LAND OF OZ

With gondola chairlifts and a ski village already in place, and a desire to provide year-round employment, the Robbins brothers decided to build a summer theme park at the top of Beech Mountain. They enlisted the visionary skills of Jack Pentes, a designer from Charlotte who had worked with them on previous projects. Pentes had always loved the *Wizard of Oz* movie. He felt the magic of Oz in the wind-bent trees with their gnarled and twisted arms, the natural caves, the imposing rock formations, and the glossy, emerald-green grass. Grover Robbins approved the concept, and construction began in 1968. On June 15, 1970, the park opened, and in its first year drew 400,000 visitors, making it the state's top tourist attraction.

Visitors arrived at Oz via bus or chairlift. From the entry fountain, they climbed to the overlook gazebo and descended to Uncle Henry's farm. Beyond the barn and petting zoo, they entered the farmhouse, escorted by one of the many tour guides playing the part of Dorothy. In the kitchen, Dorothy announced an approaching tornado and ushered her guests through a corridor of whirling sounds and images into an identical house that had been hit by the tornado, with sloping floors and furnishings all askew.

Beyond the house was the yellow brick road into the Land of Oz. After Munchkinland, with its colorful flowers and mushrooms, the first stop was the Scarecrow's house, then the Tin Man's, the cave of the Cowardly Lion, and finally the witch in her spooky castle, a comical figure who could not remember the ingredients in her stew.

At the gate to the Emerald City, Dorothy said goodbye. Beyond the gate was an amphitheater where the Oz story was completed. Another Dorothy was carried away by a balloon. Tourists could then visit the shops in the gingerbread village, which offered over-the-rainbow-themed merchandise and food.

After the bankruptcy in 1975, the Land of Oz passed to the mortgage company Tri-South. That winter a fire swept through the park, but it was rebuilt and reopened by Col. Norm Smith in 1976. It operated until 1980, when it closed for good.

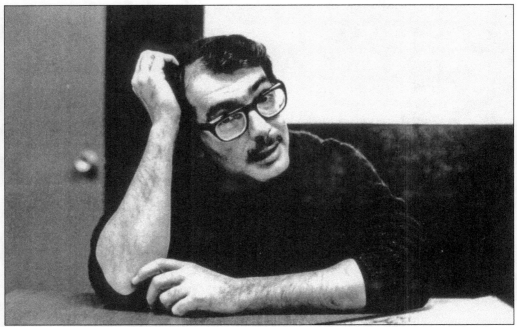

JACK PENTES. When the Robbins brothers took him to the top of the mountain by four-wheel drive, the Charlotte artist felt the gnarled beech trees reaching out to him, recalling the apple trees from the Oz movie. He envisioned the cave of the Cowardly Lion, the path of the yellow brick road, the location of Dorothy's house, and the Emerald City. It was, he recalled, a magical moment. "It was all so preordained," Pentes said. (Courtesy of Cindy Keller.)

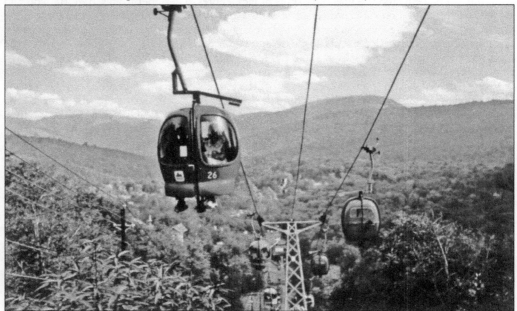

OZ LIFT GONDOLA. Visitors were escorted to Kansas via bus or red, yellow, or blue gondola chairlifts. Long-range views of the majestic surrounding mountains enhanced their over-the-rainbow experience. (Courtesy of Cindy Keller.)

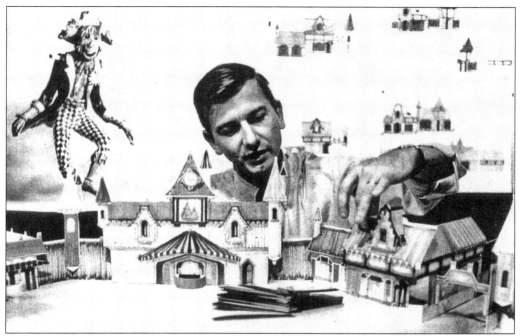

JOE SONDERMAN. As design director for Pentes Design, Inc., Sonderman supervised the execution and construction of the park. The Oz movie was only used as inspiration. In Pentes's interpretation, the characters had real homes: the Scarecrow, a painted cottage; the Tin Man, a metallic shack; the Lion, a cave. The project employed local craftsmen and retained the beauty of the mountaintop setting, with only one tree destroyed. (Courtesy of Cindy Keller.)

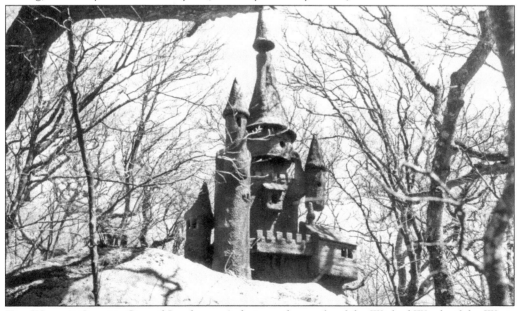

THE WITCH'S CASTLE. One of Sonderman's designs, the castle of the Wicked Witch of the West, was a place more comical than scary. Here the scatterbrained witch stirred her stew and ruined batches of magic potions. (Courtesy of Cindy Keller.)

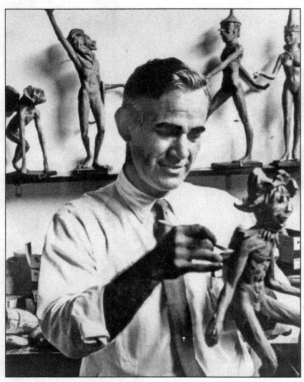

FROM PLAYBOY TO OZ. Charlotte sculptor Austin Fox, well known for the "femlin" figures he created for *Playboy* magazine, was the subcontractor for all the dimensional work. He interpreted the look of the Oz characters in sculpture. (Courtesy of Cindy Keller.)

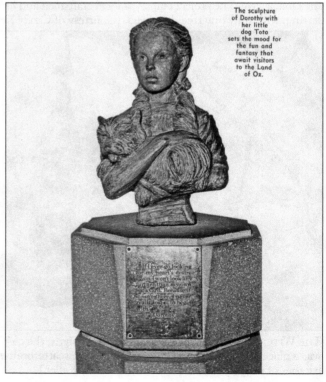

The sculpture of Dorothy with her little dog Toto sets the mood for the fun and fantasy that await visitors to the Land of Oz.

DOROTHY AND TOTO. The centerpiece of Austin Fox's work, a bust of Dorothy and Toto, commanded the place of honor in the Judy Garland Memorial Overlook Gazebo, which towered at a 5,600-foot elevation above the valley below. (Courtesy of Cindy Keller.)

LOONIS MCGLOHON. Charlotte pianist McGlohon wrote the score. His friend, legendary New York composer Alec Wilder, collaborated and fell in love with the mountain. As Mary Mayo sang, "The sky is a blue and white marble today / And a tangerine sun wants to stay out and play. / Believe it or not, every day looks this way / In the wonderful Land of Oz." "Over the Rainbow" was the only song from the movie used in the park. (Courtesy of Cindy Keller.)

CHOREOGRAPHY AND COSTUMES. The well-known choreographer Alice Leggett LaMar created dances and movements for the characters. The costumes were made by the Brooks Van Horne Costume Company of New York City. (Courtesy of Cindy Keller.)

CUTTING THE RIBBON. Actress Debbie Reynolds cut the ribbon on June 15, 1970. Sadly, Grover Robbins had died three months earlier. A frantic push to finish the park culminated in Pentes's speech to the workers. "This is not Grover's land," he said. "This isn't Carolina Caribbean's land. It is God's land and it belongs to everybody. Shortly, it will belong to millions who have never seen it before. Only you can accomplish that." (Courtesy of Cindy Keller.)

OPENING DAY, WITH ALI. From left to right, Carrie Fisher, daughter of Debbie Reynolds, Jack Pentes, and Debbie Reynolds enjoy the "Magic Moment" show in the Emerald City amphitheater. Boxing legend Mohammed Ali was also in attendance, one of 4,000 opening-day visitors. (Courtesy of Cindy Keller.)

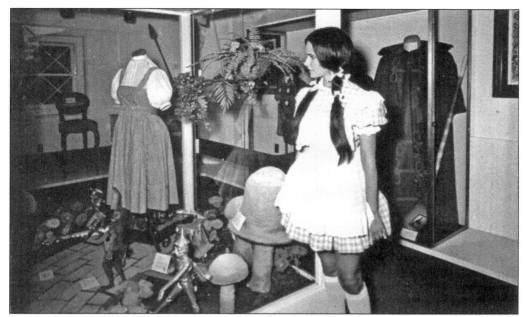

THE OZ MUSEUM. After disembarking from the bus or gondola chairlift, visitors explored the museum, featuring Dorothy's original dress from the movie and other items Spencer Robbins purchased at MGM's liquidation auction. Robbins was authorized to spend $25,000, with a limit of $15,000 for the ruby slippers. He was outbid for the slippers but acquired the dress for $1,000, and other costumes and props. (Courtesy of Cindy Keller.)

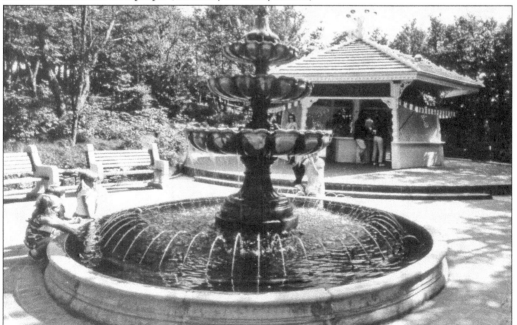

ENTRANCE AT THE FOUNTAIN. A picturesque entry fountain, occasionally frozen into an ice sculpture in early spring or late fall, welcomed guests to the beginning of their journey through the Land of Oz. (Courtesy of Cindy Keller.)

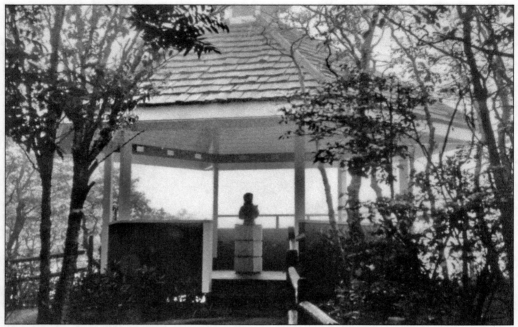

JUDY GARLAND MEMORIAL OVERLOOK GAZEBO. The strains of "Over the Rainbow" and the bust of Dorothy with Toto enchanted gazebo visitors, as did stunning views of the Elk Valley. The workmen building this edifice, which jutted out over rough rocks and boulders, spoke in awe of the difficulties of building this "gaze-bow." (Courtesy of Cindy Keller.)

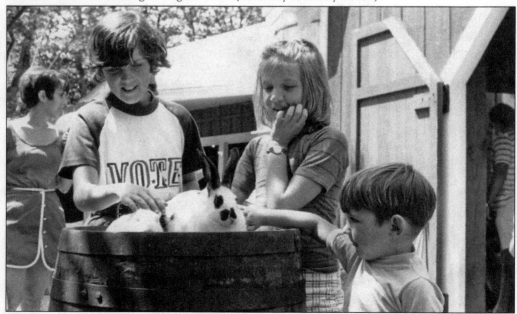

THE PETTING ZOO. The path from the gazebo led visitors down to Uncle Henry's farm, which included a barn, a silo, a windmill, and a small vegetable garden. Children especially enjoyed the petting zoo, sponsored by Purina. When the animals grew too large, they were replaced with younger ones. (Courtesy of Cindy Keller.)

DOROTHY'S HOUSE. Uncle Henry and Auntie Em's farmhouse was built to five-eighths scale. One of the Dorothy tour guides met her guests on the porch and ushered them into a typical early-1900s Kansas living room and kitchen. Then the wind picked up, and Auntie Em's voice urged the group into the cellar, where projected images of animals, houses, and even the witch flew by. (Courtesy of Cindy Keller.)

AFTER THE TORNADO. The duplicate farmhouse was built a story lower than the first one and on a 15-degree angle, creating a disorienting effect. It is said that the men building the structure could work only 20 minutes at a time without becoming ill. Visitors staggered around the disheveled rooms and hastened to follow Dorothy outside. (Courtesy of Cindy Keller.)

THE RUBY SLIPPERS. As guests exited the house, they saw the ruby slippers on the remains of the Wicked Witch of the East poking ominously from beneath the porch. Pentes put Oz in the backyard of the house because in the movie, when Dorothy got back to Kansas, she said, "If I ever go looking for my heart's desire again, I won't look any farther than my own backyard. If it isn't there, I never really lost it to begin with." (Courtesy of Connie Bowen.)

THE YELLOW BRICK ROAD. Pentes concluded that Oz was not really so far away. It was nestled in the backyard of a little girl's imagination. And so the yellow brick road, consisting of 40,000 glazed yellow bricks, led the way through the magic that was Oz. (Photograph by Ralph Miller.)

VISITING THE SCARECROW. Pentes wanted visitors to experience Dorothy's journey down the yellow brick road. Passing through Munchkinland, where brilliantly colored flowers, tiny houses, and foam mushrooms dotted the landscape, they arrived at the home of the Scarecrow, who came out and joined Dorothy in a dance and song, "I Wish I Had a Brain." (Courtesy of Cindy Keller.)

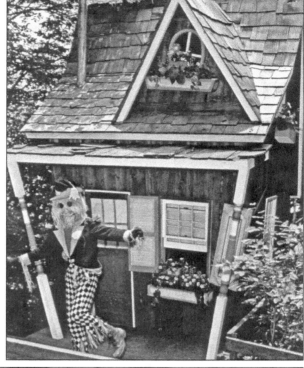

THE TIN MAN. Next, the Scarecrow directed everyone to a rusty shack, where the Tin Man emerged and performed a creaky soft shoe dance with Dorothy. His plaintive song lamented, "I Lost My Heart, and I Don't Know Where to Find It." (Courtesy of Cindy Keller.)

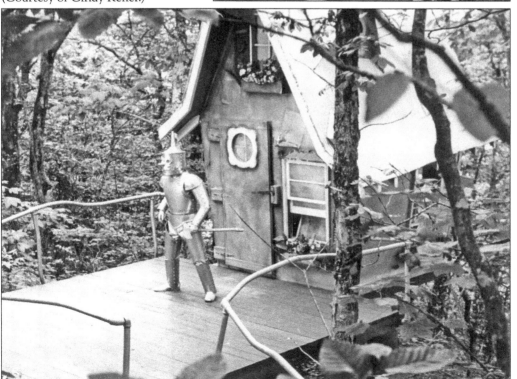

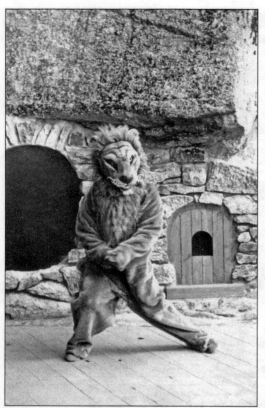

THE COWARDLY LION. On down the road was the Cowardly Lion's den. After a courageous leap from his cave, he waltzed with Dorothy and admitted in song, "I'm a Scairdy Cat." (Courtesy of Cindy Keller.)

THE WICKED WITCH OF THE WEST. The approach to the witch's castle darkened as she suddenly appeared, whirling about and cackling over her pot of potions, "How do I brew this stew? Now what's the first thing I do?" Songwriters McGlohon and Wilder did not want the witch to frighten children, so they humanized her. As she bumbled about, she became more comical than menacing. (Courtesy of Cindy Keller.)

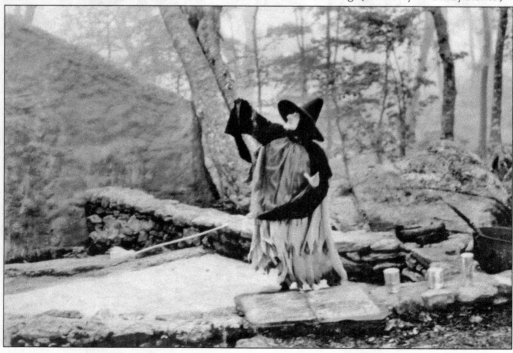

SINISTER TREES. Some of the gnarled beech trees were embellished with fearful faces. One in particular, hanging with shiny apples, scolded Dorothy when she attempted to pick one of its apples. (Courtesy of Cindy Keller.)

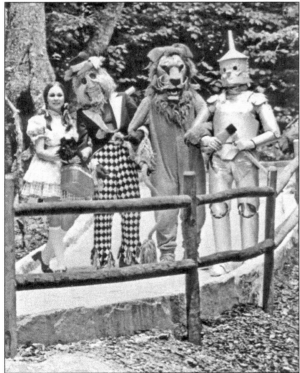

OZZIES. Actors and other employees at the park were known as Ozzies. They were college and high school students, mostly from neighboring counties, who responded to advertising and casting calls. Many hoped to become professional actors. Others simply wanted an interesting summer job. There were a number of Dorothys. Some escorted visitors; others had parts in the Emerald City show. (Courtesy of Cindy Keller.)

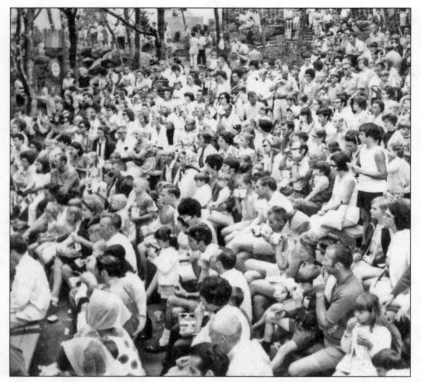

AN EMERALD CITY AUDIENCE. Dorothy told her guests goodbye at the gates to the Emerald City. Munchkin girls singing "Have you come to see the Wizard?" passed out greenie glasses that made the surroundings appear in their proper hue. The 15-minute Magic Moment stage show took place every hour, drawing large audiences. (Courtesy of Cindy Keller.)

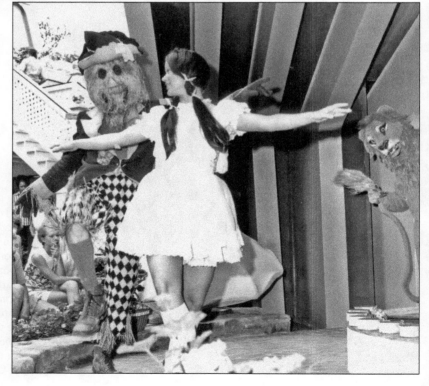

DOROTHY ON STAGE. During the show, Dorothy danced and sang with the characters while awaiting their audience with the all-powerful Wizard of Oz. (Courtesy of Cindy Keller.)

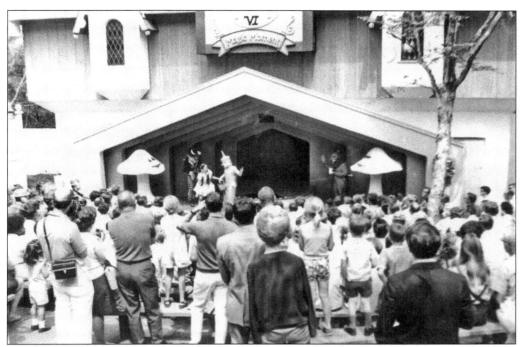

MAGIC MOMENT. A projected image of the Wizard awarded the Scarecrow a diploma, the Tin Man a heart, and the Cowardly Lion a medal. In the grand finale, after singing "Over the Rainbow," Dorothy clicked her heels together three times and disappeared in an explosion of smoke. The characters ran back on stage, pointing and waving to an identical Dorothy carried overhead by a balloon, on her way home to Kansas. (Courtesy of Cindy Keller.)

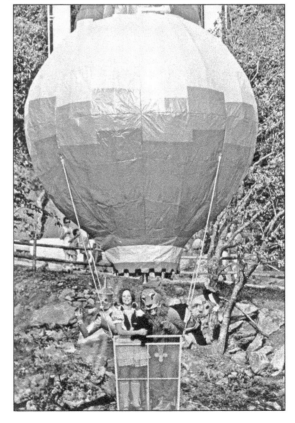

BALLOON RIDES FOR ALL. When the show ended, Emerald City visitors were invited to ride in one of the 28 colorful balloons that circled the park, suspended by a converted chairlift. This was the park's only ride. Guests also enjoyed the Rainbow Restaurant, the munchkin souvenir shop, and a number of stores selling clothing, ice cream, and candy. (Courtesy of Cindy Keller.)

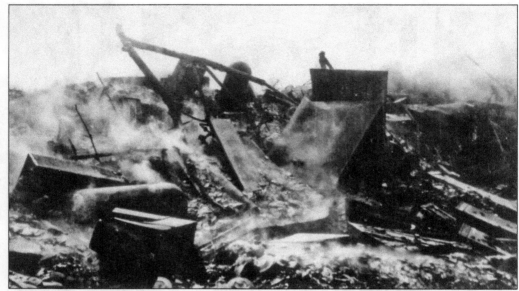

FIRE AND VANDALS DEVASTATE OZ. In late December 1975, a fire destroyed the Emerald City theater, including all the costumes and audio and visual equipment. The museum that contained many items from the movie purchased at the MGM auction was vandalized, and a number of artifacts, including Dorothy's dress, were stolen. (Courtesy of Col. Norm Smith.)

REBUILDING OZ. The title to the Land of Oz passed to the mortgage holder, Tri-South of Atlanta, following the bankruptcy of Carolina Caribbean Corporation. Tri-South hired Col. Norm Smith to supervise the reconstruction and manage the park. (Courtesy of Col. Norm Smith.)

DOROTHY LEADS THE WAY. After the park reopened, there were many changes. All the costumes had a new look and, in place of masks, the faces of the characters were painted. The costumes, made by Morris Costumes of Charlotte, relied on designs influenced by the movie. (Courtesy of Col. Norm Smith.)

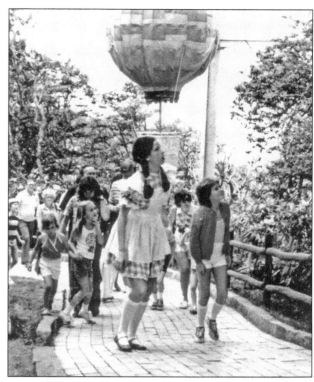

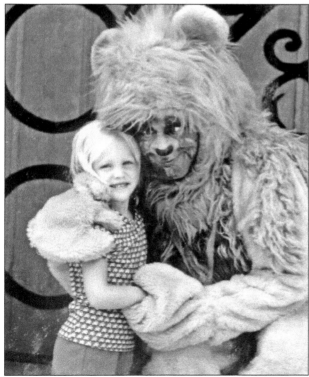

THE CUDDLY LION. One of the most wonderful aspects of the Land of Oz was the way the characters related to the children. After each Magic Moment performance, there was a time for boys and girls to visit and have their pictures made with the Scarecrow, the Tin Man, and the Cowardly Lion. (Courtesy of Col. Norm Smith.)

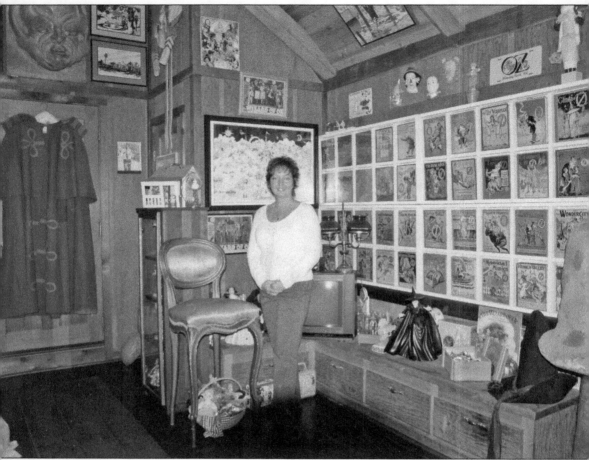

CINDY KELLER. Gasoline shortages, recession, and competition from other attractions all had adverse effects on attendance at the restored Land of Oz. Higher insurance and maintenance costs added to its financial problems. Management considered Pentes's estimate for expansion and needed repairs—$3 million—out of reach. In October 1980, the park closed for good. For 10 years it lay dormant, a victim of fierce winters, fire, and vandals, becoming overgrown with brambles and the yellow brick road buried under rotting leaves. The property reverted to the Hufty family, who had leased it to park developers. The dark decade ended when Cindy Keller became broker and property manager for the Huftys. She wanted to develop the 450 acres into an upscale community. Although the Emerald City was bulldozed, much of the park was restored, including Dorothy's house, Uncle Henry's barn, and the witch's castle. (Photograph by Ralph Miller.)

THE NEW OZ MUSEUM. The original Land of Oz museum is now the winter quarters of the Ski Beech Ski Patrol. Cindy Keller has created a new museum in Uncle Henry's updated barn, with artifacts from the *Wizard of Oz* movie that were rescued after the fire and vandalism at the park. The exhibition includes memorabilia from the Land of Oz and an assortment of Oz-related items, including a group of Madame Alexander Oz dolls. It also houses a complete collection of Frank Baum's famous Oz books. The barn is also home to Keller and her construction-savvy husband, Andy Porter, whom she credits for translating her visions into new and restored buildings. (Photographs by Ralph Miller.)

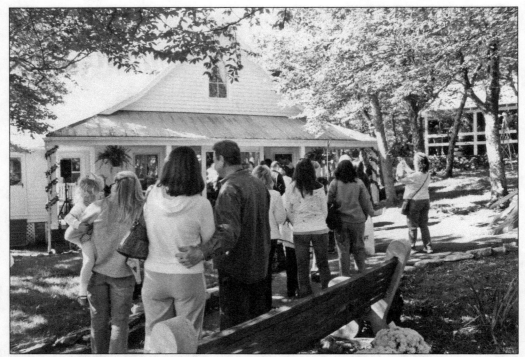

VISITORS TO DOROTHY'S HOUSE. Many people remembered Oz and were distressed by its closing. In 1993, Keller reopened what remained of the park for a one-day Autumn at Oz party. Some 500 people came to the party. By 2008, attendance had grown to over 8,000 in a two-day event the first weekend in October. Visitors walk or ride a bus or hay wagon to the top of the mountain. (Courtesy of Cindy Keller.)

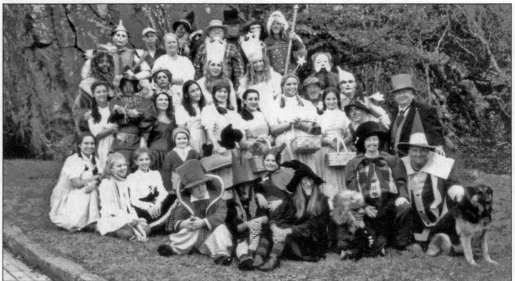

A NEW CAST OF ENTERTAINERS. A large cast of actors and an assortment of volunteers participate in the Autumn at Oz festivities. Cindy Keller, who calls herself the "Keeper of Oz," is resplendent as the mayor of Munchkinland. (Courtesy of Cindy Keller.)

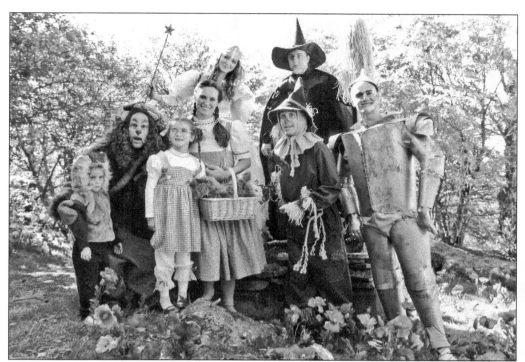

PHOTOGRAPH TIME. What fun to dress up and have your picture made with your favorite Oz characters! Young and old are encouraged to wear something Oz-like to the Autumn at Oz party. There are many opportunities for photographs along the yellow brick road. (Photograph by Ralph Miller.)

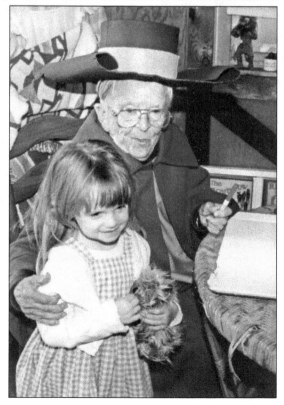

MEINHARDT RAABE, MUNCHKIN CORONER. The Munchkin coroner from the *Wizard of Oz* movie was a featured guest at many of the Autumn at Oz parties. Raabe enjoyed talking with the children and repeating his famous declaration concerning the death of the Wicked Witch of the East: "As coroner I must aver / I thoroughly examined her, / And she's not only merely dead, / She's really most sincerely dead!" (Courtesy of Cindy Keller.)

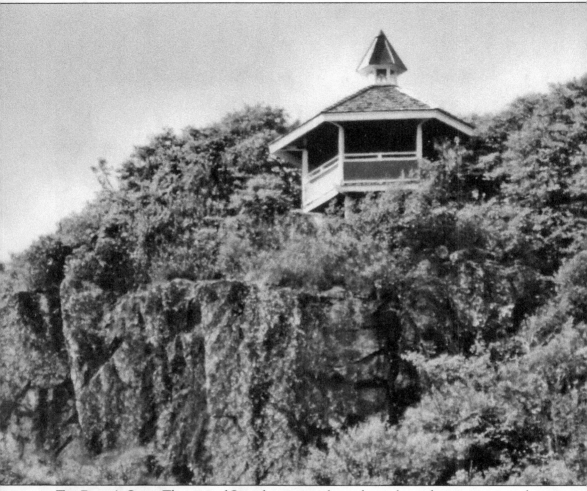

THE PARTY'S OVER. The story of Oz ends as visitors leave the enchanted mountaintop and return home. Those who have come to reminisce and introduce their children to the magic they remember from their own childhood are already looking forward to next year. Oz, like Brigadoon, now comes to life only one time a year, offering Dorothys and scarecrows, tin men and lions, witches and flying monkeys, and the celebrated yellow brick road. The music of McGlohon and Wilder echoes through the air: "Do you know another place scarecrows can dance, / And where else could you speak to a lion by chance, / Or see a man wearing aluminum pants? / In the wonderful Land of Oz." After a last look up the mountain, click your heels together three times and think of a rainbow . . . a rainbow . . . a rainbow. (Photograph by Ralph Miller.)

Six

THE POA AND THE CLUB

The Beech Mountain Property Owners Association (POA) was created by Carolina Caribbean Corporation "to promote the health, safety, and welfare of property owners." The organization took on a more specific and important role during the six critical years from the time the corporation failed in 1975 to the formation of the town in 1981. Owners knew property values would plummet unless they could find a way to pick up the pieces in the wake of the bankruptcy. The leaders in securing the future for the town and the club were the POA members; past president and past executive director, retired Col. Jim Hatch; POA president Hunter Furches; and retired Col. George Handley, who became the executive director in 1974.

The POA's new mission was "to own, acquire, build, operate, and maintain recreation facilities as the members may desire." Its first major challenge was to open the ski slopes for the 1975–1976 season. There was no management structure left, but to close for a season would further tarnish the ski resort's reputation.

That summer the ski area and the Land of Oz were released from bankruptcy to Tri-South Mortgage Corporation, which brought in another military retiree, U.S. Air Force Col. Norm Smith, to manage them. The POA board negotiated the purchase of the golf course from North Carolina National Bank for $800,000 and the recreational facilities for $50,000. A $400,000 loan to cover part of the purchase was repaid promptly through an owner-approved assessment.

The next step in securing the community's future was to provide for its governance. Col. George Handley led the POA through the arduous process of incorporation, and in 1981, the state granted a charter for the Town of Beech Mountain. To provide ongoing management of the resort facilities, the POA reorganized as the Beech Mountain Club. By 1985, the club had repaired the golf course irrigation system and the pool, and had expanded the tennis complex. Club membership grew to approximately 1,700. In November 1999, Brian Barnes was hired as club manager, and under his professional leadership and direction, the Beech Mountain Club has thrived.

The club has continued to improve its facilities. The current clubhouse, with a magnificent view of the surrounding mountains, is a fitting tribute to the early property owners who were determined to preserve the community and build one of the finest clubs in the High Country.

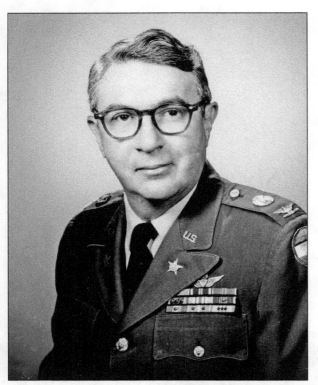

Col. George Handley. With Hunter Furches as POA president, Colonel Handley became executive director, which had become a full-time paid position. His firm leadership during the bankruptcy and the six years before the POA split into the club and the town in 1981 saved property values, the ski slopes, the recreational facilities, and the town's infrastructure. (Courtesy of Col. George Handley.)

Rachel Deal, Secretary Extraordinaire. As POA secretary until 1985 and in several earlier positions in the Carolina Caribbean Corporation office, Deal demonstrated enthusiasm for the developing community at Beech Mountain. (Courtesy of the Beech Mountain Club.)

KEEPING THE SLOPES OPEN. Hunter Furches played an important role in protecting property owners' investments. In 1975, the bankruptcy trustee agreed to turn over ski operations to the POA. Furches had no experience running a ski resort, but he took on that challenge for the 1975–1976 season. Fortunately it was a mild, short winter, and he was able to close in February without damaging the resort's reputation. (Courtesy of Jan Furches Roberts.)

SUMMER RECREATION. Using a tree stump for a golf tee is unorthodox, but Ralph Gwaltney seems to be doing it. Colonel Handley negotiated the purchase of the golf course and the 13-acre recreation area. Fred Pfohl, the first recreation director, operated out of a double-wide trailer adjacent to the tennis courts. The day camp and tennis pro shop were also located there. (Courtesy of Fred Pfohl.)

A SIGNATURE HOLE. Beverly Cameron tees off on number nine on the Beech Mountain course in 1978. The first nine holes were built in 1969, and nine more were completed in 1971. Through the years the course has undergone a number of renovations and improvements. Under course superintendent Rory Ellington, it is a facility rivaling any in the High Country. (Courtesy of Beverly Cameron.)

LEADERSHIP ON THE COURSE. Under club general manager Brian Barnes (left) and head golf pro John Carrin, the golf course added a new and much-improved practice area, a new cart barn, and an expanded pro shop. In addition to instruction, Carrin and his staff organize activities for the Men's Golf Association and the Ladies Golf Association, the Lady Niners, charity events, club championship tournaments, and interclub matches. (Courtesy of Karen Brett.)

THE ORIGINAL CLUBHOUSE. Built by Carolina Caribbean Corporation, the first clubhouse perched on a rocky precipice, affording a breathtaking view of the golf course and the mountains to the north. The dining room and pro shop were upstairs, with locker rooms, a bar, and an outdoor patio below. In 1997, a new clubhouse was built on the same site, with expanded kitchen and dining areas, club and card rooms, and two bars. (Courtesy of Beverly Cameron.)

FIRST NEW CONSTRUCTION. In 1990, the reorganized club built its first new facility, a freestanding golf pro shop. Board president Ralph Bailey (left) and general manager Bill Sposato cut the ribbon. The Fairway Cafe and new maintenance buildings were added later. (Courtesy of the Beech Mountain Club.)

TENNIS, ANYONE? Tennis pro Tim Smith (left) and his assistant Jaco Kruger became very popular with the tennis set. Smith was hired in 1987 and became head pro two years later. His clinics are well attended, and he is in demand for private lessons. He also runs a successful children's program. Smith hosts weeklong tennis camps to help players get in shape for the summer season. (Courtesy of Tim Smith.)

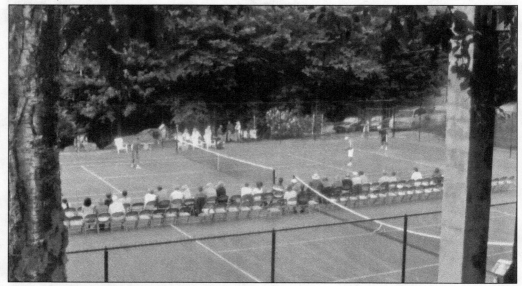

TENNIS PRO CHALLENGE. Spectator tennis at Beech got a boost in the early 1990s when pros from the surrounding area were first invited to play Tim Smith and his assistant. The outstanding level of play draws large numbers of fans that cheer for their club pros. A buffet supper for players and fans ends the popular event. (Courtesy of Tim Smith.)

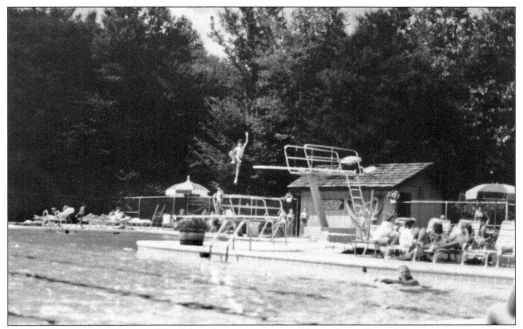

OLYMPIC SWIMMING POOL. The heated swimming pool has always been the centerpiece of the summer recreation program. The original pool built by Carolina Caribbean Corporation became a liability because of its deep diving area. In 1994, it was replaced with a facility with a separate children's pool and no diving area. (Photograph by Terese Barry.)

JUMPING JACKS AND JILLS. Water aerobics class is a popular pool activity. Lap swimmers, day campers, and families also enjoy the pool. In 2008, the club built a new pool incorporating up-to-date designs and special water features for children. A new entry building and reconstructed pool house provide space for an upstairs yoga room. The Pump House, a poolside cafe, serves snacks and drinks. (Photograph by Marge Bailey.)

CAMPING FUN AND GAMES. Day camp for kids and grandkids began in Carolina Caribbean Corporation days and continues to be an important summer activity. For many years, the day camp was located in the lower level of the recreation building. Now adjacent to the pool area, the facilities include a playground, an activities building, and two craft huts. (Photograph by Connie Bowen.)

SUNSET PICNICS. Members enjoy outdoor activities, particularly if they include meals. One summer, March Terrell (left) and Jim Brooks prepared food for Sunday evening picnics with short hikes to sunset viewing overlooks. Fred Pfohl, the first recreation director, introduced tubing, canoeing, and train and raft excursions. Hikes were organized by Anne and Eckess Jones, with vans to take hikers to trailheads in the area. (Courtesy of the Beech Mountain Club.)

JAN CALVIN. One of the club's most beloved recreation directors was Jan Calvin (standing), who developed a program for all ages and interests. She especially enjoyed entertaining at the old mill, which was built around a log cabin brought from Jonesborough, Tennessee, and reassembled on Calvin's property. The mill played host to pig roasts, wine tastings, craft classes, wildflower walks, and ladies' luncheons. (Courtesy of the Beech Mountain Club.)

RECREATION BUILDING. For many years, the recreation building was known as the administration building. It housed club management and the tennis pro shop as well as the recreation office. In 2002, the Trillium Building was constructed to accommodate enlarged administrative and tennis facilities and a state-of-the-art fitness center. The former tennis pro shop now serves as a lending library staffed by dedicated club volunteers. (Photograph by Marge Bailey.)

POLICE JOIN FESTIVITIES. Hobert Watson (right) and friends enjoy a Beech Mountain luau. Watson was a highly regarded, longtime chief of security for the Property Owners Association. In 1981, when the town was formed, he became the first police chief. (Courtesy of Marge Bailey.)

PARTY TIME IN THE PAVILION. After a number of pool parties and other outdoor activities were cancelled due to inclement weather, the club built a pavilion above the pool area in 1993. It became a popular venue for private parties, luaus, square and line dancing, bingo, covered dish dinners, and aerobic classes. Members also play boccie ball on a court built beside the pavilion. (Courtesy of the Beech Mountain Club.)

TIME TO SMELL THE FLOWERS. Weekly nature walks were some of the first recreation activities. Charlie Burleson led tours of the mountain, introducing members to the native flora and fauna. Marge Bailey has continued the tradition, with Nature Venture day trips to interesting sites off as well as on the mountain. Now a 24-passenger bus provides a comfortable ride to craft shows, theater performances, and concerts. (Photograph by Linda Olsen.)

HATS, HATS, HATS. The Recreation Activity Room has been home to a variety of crafts classes as well as member craft and art shows. The room also hosts weekly bridge games and a professionally staffed health fair checks on members' well-being every year. All the events are publicized at the annual Mimosa Morning celebration that launches each new summer season. (Courtesy of the Beech Mountain Club.)

THE ALPEN HAUS. The club's winter clubhouse sparkles under a fresh blanket of snow. It was built in 1991, with an addition constructed in 2001. Popular tennis pro Tim Smith was for many years the Alpen Haus manager, assisting member skiers with food, drinks, and lift tickets. When the snow melts and slopes close, the Alpen Haus is a favorite location for summer activities. (Photograph by Ralph Miller.)

WINTER PEOPLE PARTY. During the winter, visiting skiers and year-round residents enjoy socializing and exchanging stories of fun on the slopes and troubles on the icy roads. They owe thanks to the early directors of the POA and the Beech Mountain Club for preserving the club as truly a place for all seasons. (Courtesy of the Beech Mountain Club.)

Seven

THE TOWN

Eastern America's highest incorporated town began with the formation of the Sanitary District in December 1978, which was approved by the North Carolina General Assembly in September 1980 as requested by the Property Owners Association and other concerned citizens. The Sanitary District was a key factor in keeping Beech Mountain a viable place to live because it owned and operated the water and sewer systems in the critical period following the bankruptcy of Carolina Caribbean Corporation. After a series of public hearings, the town was created by General Statute #S 130-126.1 in May 1981, becoming the fourth municipality in Watauga County. The state appointed the members of the first town council, who served until the general election in November. In approximately one year, the Sanitary District was dissolved, and the town absorbed its debt and assets, thus eliminating dual responsibilities.

The chamber of commerce was formed in November 1981. The volunteer fire department, created in 1971, continued to serve the community after the town was incorporated. Col. Gordon Ripley served as the first fire chief, followed by Bill Owen and Col. Jim Hatch. A unique feature of the department is that, like the town, it sits in two counties, Watauga and Avery.

The year 1981 was busy. The police department was established in July. Ed Jones was hired to fill three positions: town manager, clerk, and finance officer. In the November election, the largest vote went to Fred Pfohl, who was then chosen as mayor by the rest of the new council, which included Lt. Col. Reub Mooradian, Kathleen Handley, Wilson King, and Edwin Lotz. Unlike most towns, Beech Mountain has no schools, no banks, and despite miles of roads, no traffic lights. But many problems faced the new town. Road paving was a major issue, along with water and sewer services. Construction began in 1985 on Buckeye Lake, which would serve as the town's primary water source.

The council passed an ordinance in 1985 to allow the sale of liquor by the drink. Through the years the town has also sponsored many events. It was part of the Tour DuPont, America's premier cycling event from 1993 through 1996. Whether it is the Pig Roast, the Kite Festival, or the Cool Five Run, an array of activities provide residents and visitors, whether spectators or participants, with experiences to remember for a lifetime.

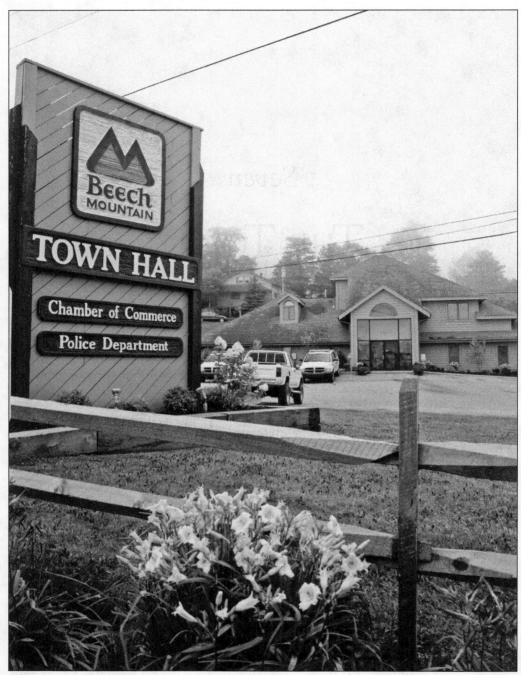

WELCOME TO TOWN HALL. At the crest of the almost 4-mile climb from Banner Elk on Highway 184, motorists will see the town hall on the left. It was completed in 1989, eight years after the incorporation of the Town of Beech Mountain, and it serves both residents and visitors. The town operates under a council-manager form of government. The council selects a mayor from its five members, and the mayor serves as council chair. The town has approximately 55 employees. (Photograph by Ralph Miller.)

BIRTH OF A TOWN. Robert Lacy swears in Vernon Holland as interim mayor of Beech Mountain, the state's newest town. Holland served until an election was held in November 1981. The interim council members were Edwin Lotz, retired special forces Lt. Col. Reuben Mooradian, Fred Pfohl, and retired special forces Col. Gordon Ripley. (Courtesy of Vern Holland.)

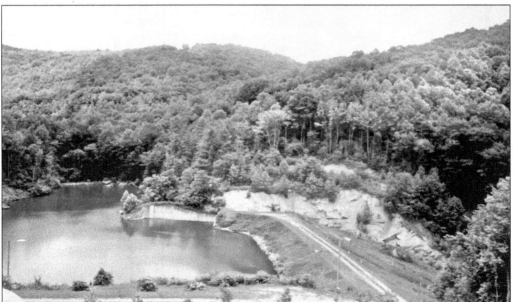

BUCKEYE LAKE COMPLETED. The Buckeye Lake Recreation Area was a major goal for the first town council in 1981. A state grant provided $36,500, and the town created a Land and Funding Program for an additional $50,000. The lake, the town's primary water source, was completed in 1986, stocked and approved for small boats, and included a picnic shelter, restrooms, parking, and a hiking trail. (Photograph by Dolan Carpenter.)

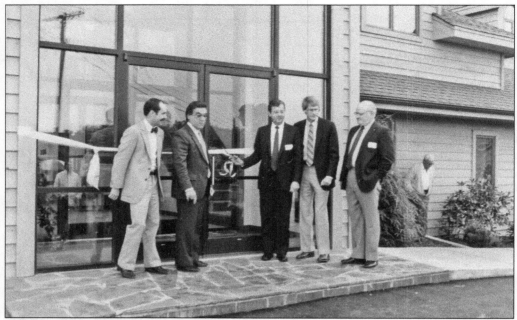

OPENING TOWN HALL. On September 29, 1989, state senator Donald Kincaid cuts the ribbon to open the town hall building. Also joining in the ceremony were (from left to right) council member Tim Holland, Mayor Rick Miller, and council members Wilson King and Alan Holcombe. The town government serves more than 350 full-time residents. (Courtesy of Rick Miller.)

NEW OFFICES CREATE SMILES. Town clerk Barbara Mooradian (center) places a call while Carolyn Smith (left), the utilities billing clerk, and tax collector Missy Norwood take a break. In 1989, the chamber of commerce was a tenant in the town hall. It moved to a new Visitors Center in 2000. (Photograph by Rick Miller.)

RIBBON CUTTING FOR 911. The new 911 center opened for business on September 1, 1992. Among those present were (from left to right) police chief Jay Hefner, Mayor Rick Miller, and Watauga County sheriff Red Lyons. (Courtesy of Rick Miller.)

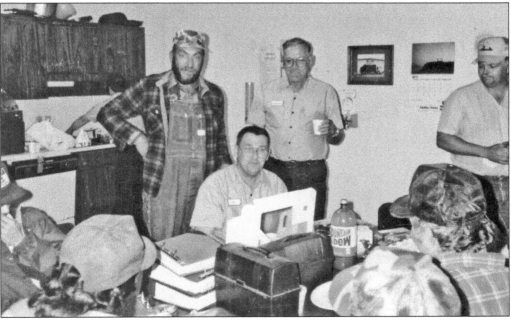

LUNCH AT PUBLIC WORKS. With the completion of the town hall, the public works department occupied the entire complex it had shared with the rest of the town government. Joe Perry was the public works director until his retirement in August 2000, when Riley Hatch succeeded him. The photograph shows, from left to right, Bob Gragg, Joe Perry, Leonard Watson, and Terry Turbyfill enjoying lunch in the public works common room. (Courtesy of Dolan Carpenter.)

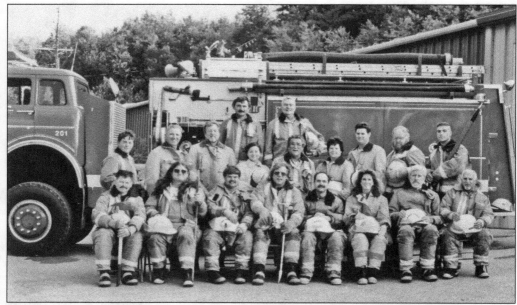

FIRST LINE OF DEFENSE. The Beech Mountain Volunteer Fire Department shows off one of its trucks and well-equipped volunteers. The department had two long-term chiefs, Lt. Col. Reub Mooradian from 1974–1994, and after a two-year term by Tim Holland, Jim Brooks from 1996 until this writing. The department has two stations, one off Beech Mountain Parkway and the other on St. Andrews Road. (Courtesy of Jim Brooks.)

FIREMEN'S FUND-RAISING GALA. The volunteer fire department has been raising money to purchase equipment and maintain trained volunteers for over 30 years. This picture shows, from left to right, Tom and Jenny Frazier and Chief Reub Mooradian and his wife, Barbara, enjoying the festivities of the annual fund-raising gala, held the first weekend in August. (Courtesy of Jim Brooks.)

FRED'S GENERAL MERCANTILE. Marge and Fred Pfohl eyed a peculiar parcel of property on Beech Mountain Parkway. It was long and narrow, but it seemed to them a good spot to build an old-fashioned general store. They bought it on the courthouse steps through the bankruptcy court in 1978. The store stocks almost anything residents and visitors might need, including hardware, groceries, fresh produce, wine, beer, clothing, shoes and boots, souvenirs, ski rentals, birdseed and feeders, newspapers, magazines, books, video rentals, and toys. Fred's motto is, "If you don't see it, ask for it. If we don't have it, you don't need it." Morning customers are lured by the smell of freshly baked pastries from the deli downstairs, which serves breakfast as well as sandwiches, soups, Fred's chili, pizza, daily specials, and ice cream. Fred's is also the first stop for many visitors needing directions or other information about Beech Mountain, and the place where residents can pick up on conversation about community issues and activities. (Courtesy of Fred Pfohl.)

GROUND-BREAKING FOR FRED'S.
Construction took only five months to complete because the crew worked six days a week through snow and blustery winter weather. Selling wood and plowing snow helped the Pfohls make a living for themselves and the four children still at home. Pictured from left to right are Arnold Helms, Fred Pfohl, Jim Brooks, and Jimmy Stegall. (Photograph by Paul Bousquet.)

STOCKING THE STORE. Neighbors and friends helped Fred Pfohl (left) ready the store for the grand opening on February 9, 1979. It has been open every day since. Year-round resident Ralph Bailey made the first sale. The store was not officially open yet, but Bailey was helping stock the shelves when a woman appeared at the door desperate for spaghetti sauce. He sold her a jar. (Photograph by Paul Bousquet.)

DEMO CRAFTERS AT WORK. The first Saturday in August brings vendors and shoppers to Beech Mountain for the annual crafts show. Local craftspeople display their wares in the 60 or so booths, with music and other entertainment also provided. Here two sisters, both in their 80s, Martha Hawkinson and Frances Pfohl, demonstrate rug hooking. (Photograph by Fred Pfohl.)

SUNSET CONCERTS AT FRED'S. On Sunday evenings, residents and visitors gather around Fred's gazebo to enjoy music from bluegrass to gospel and cool summer twilight temperatures. Fred's, the chamber of commerce, and various businesses have sponsored the concerts. A favorite group for years was the Bluefields. Pictured from left to right are Floyd Townsend, Melvin Turbyfill, Rebecca Eggers-Gryder, and Rick Ramsuer. (Photograph by Therese Barry.)

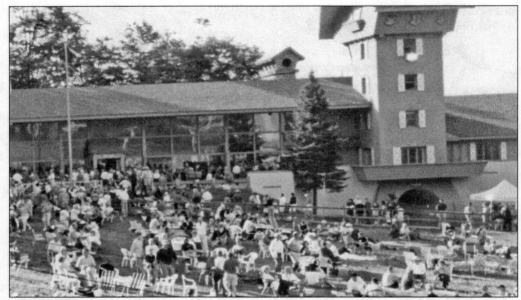

Hog Feeds Large Crowd. The first annual Roasting of the Hog was held at the home of John Wade on Overbrook Trail. This event is sponsored annually by the chamber of commerce on or around the Fourth of July, and is now held at Ski Beech along with a fireworks display. (Courtesy of Jim Brooks.)

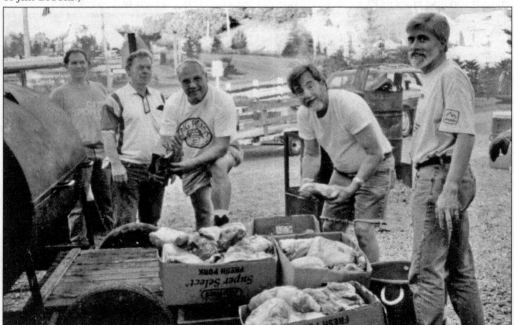

A 5 A.M. Call to Cook. Early morning volunteers oversee the smoking of 1,000 pounds of pork and 300 pounds of turkey for the annual Roasting of the Hog. Later a parade of smokers will leave Fred's parking area and proceed to the View Haus at Ski Beech. Pictured supervising the roasting are, from left to right, Jimmy King, Jim King, Pete Chamberlin, Bill Barnes, and Jim Brooks. (Courtesy of Jim Brooks.)

SERVING UP THE HOG. Volunteers Sandy and Paul Enfield are among the approximately 100 volunteers who make this event possible. Proceeds from the Roasting of the Hog go to the chamber of commerce. (Courtesy of Beech Mountain Chamber of Commerce.)

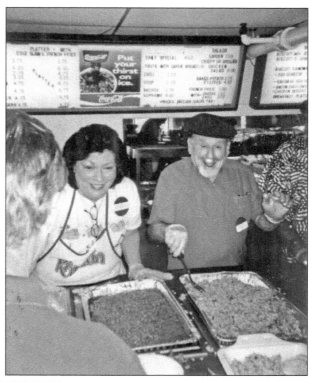

WETZEL AT THE PIG ROAST. Beech Mountain police officer Bob Johnson gives a demonstration with police dog Wetzel, also known as officer 811. After many hours of training with Johnson and officer Rene Carpenter, Wetzel served the police department and community for three years, appearing at the Pig Roast each year. He was loved by the children and adults of the community. (Courtesy of Bob Johnson.)

FRIENDS FOR LIFE. An improbable duo, Cindy Keller's dog, Fritz, and Nikki the deer, were inseparable pals. They would roam the mountain, visiting the ski slopes as well as businesses and homes. (Photograph by Cindy Keller Porter.)

GENESIS ANIMAL SANCTUARY. Started by Leslie Hayhurst, the nonprofit facility operated until early 2009 with public donations in the dome building at Buckeye Lake Recreation Area. All rescued wildlife have disabilities that prevent their release back into the wild. The resident groundhog, Sir Walter Wally, predicts the weather in Raleigh at the North Carolina Museum of Natural Sciences. Pictured are Margaret (left) and Emily Shinn feeding Gracie the deer. (Photograph by Jerry Shinn.)

RAY HICKS, NATIONAL
TREASURE. The famous
Beech Mountain storyteller
is the recipient of a lifetime
achievement award from the
Smithsonian Institution.
Hicks's storytelling started
with students at the Cove
Creek Elementary School
in 1951. He was born
on Beech Mountain in
a log cabin in 1922 and
died in 2003. (Courtesy
of Beech Mountain
Chamber of Commerce.)

PASSING ALONG MOUNTAIN LORE. The Jack tales, traditional mountain folklore presented by area storytellers, have entertained at festivals through the years. The Hicks family would gather on the porch of their cabin along with any visitor who would listen. Their repertoire includes around 50 Jack tales about the antics of boys growing up in the mountains. (Courtesy of Beech Mountain Chamber of Commerce.)

GARBAGE DAY PARADE. Beech Mountain will celebrate almost anything. The town held a parade and beauty contest to celebrate the purchase of a new garbage truck. (Photograph by Marge Bailey.)

MORE FROM GARBAGE DAY. Led by Alan Holcombe, the godfather of trash, Beech Mountain residents, many in costumes, entertained each other at a picnic and parade honoring their public works department. These unidentified ladies, "the four old bags," are part of the 1980s spirit. Satisfaction was guaranteed or double your trash back. (Courtesy of Marge Bailey.)

BED RACE ENTRY. The Beech Mountain Chamber of Commerce sponsored a day of fun and competition between the businesses on the mountain. The entry from Fred's General Mercantile is pushing baby doll Mary Sue Sposato-Driscoll, and the four horsemen are played by, from left to right, Tim Holland, Jimmy Sposato, Jim Brooks, and Stephen Sposato. (Photograph by Fred Pfohl.)

WHICH WAY TO OZ? The yellow brick road bed is occupied by slumbering Betsy Earnhardt and pushed, from left to right, by Ben Green, Riley Hatch, and Steven Holtz. (Photograph by Pat Earnhardt.)

Beech Mountain Summit Conference. Who says we can't dress up? Town council members Tim Holland (left) and Alan Holcombe hold court in Fred's Deli, dressed as members of the mafia. (Courtesy of Alan Holcombe.)

Friends of Cannon Hospital. Showing their support for Cannon Hospital in 1995 are, from left to right, Ellie Shrago, Marge Pfohl, and Annette Wolf. Residents sponsored bake sales and sold the famous *Beech Mountain Cookbook* to raise money for the hospital in Banner Elk. (Photograph by Fred Pfohl.)

KIDDO FISHING DERBY. One of Beech Mountain's most popular annual events is the Kiddo Fishing Derby, held at Lake Coffey and open to children ages 4 through 12. Prizes and trophies are awarded to both boys and girls for first trout, largest trout, heaviest trout, and the first to catch the four-trout limit. (Courtesy of Beech Mountain Chamber of Commerce.)

VOLUNTEERS GUARD TROPHIES. Donating their time and smiles at the Kiddo Fishing Derby are, from left to right, Judy Burleson, Peggy Coscia, Cindy Schoepfle, and Karen Brett. Volunteerism is the backbone of the Beech Mountain community. Without this army of friendly folks, many activities and events would never take place. (Courtesy of Beech Mountain Chamber of Commerce.)

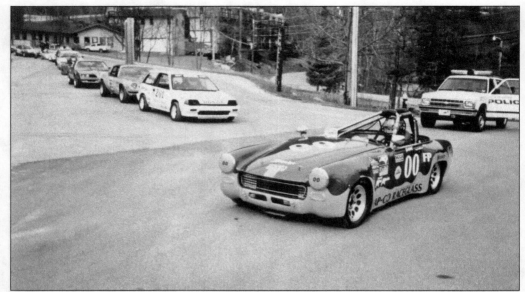

GENTLEMEN, START YOUR ENGINES. Hill climbing is nearly as old as the automobile itself. During the 1990s, usually in May and once in September, Beech Mountain gave spectators the thrill of a hill climb. The event, sponsored by the chamber of commerce and the Southeast Sports Car Club, attracted about 90 cars and drivers, racing from the Ski Beech entrance to the town hall. (Courtesy of Beech Mountain Chamber of Commerce.)

BIKING ON BEECH. The mountain provides a wonderful system of trails for mountain bikers, from novices to experts. There are seven trails with over 16 miles of spectacular and challenging terrain to satisfy all riders. In addition, the town has 51.2 miles of paved bike routes. Each of the five routes begins at the Visitor's Center adjacent to the town hall. (Courtesy of Beech Mountain Chamber of Commerce.)

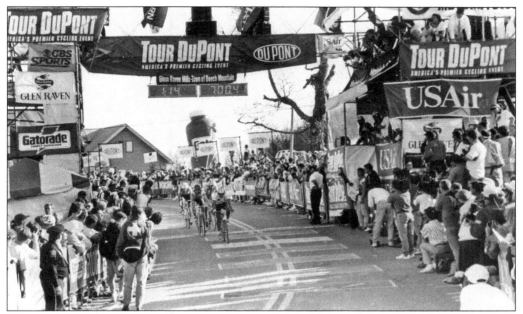

WORLD-RENOWNED BIKING DESTINATION. Beech Mountain is known to riders around the world thanks to the Tour DuPont, America's foremost road race during the 1990s. The climb up Beech was recognized as the toughest leg of all, being 4 miles long with a 2,300-foot increase in elevation. Many cyclists make the journey to Beech Mountain for high-altitude training. (Courtesy of Fred Pfohl.)

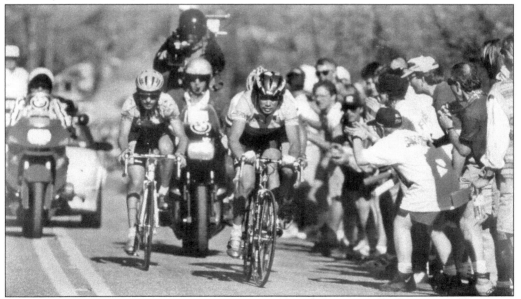

GO, LANCE, GO! Beech Mountain was the site of Lance Armstrong's Tour DuPont stage wins during the mid-1990s. He trained and then raced to victory on the mountain during those years. Beech was the highest point in the race, which stretched across several states and through the North Carolina High Country. Cyclists called the climb up Beech "the death march." (Courtesy of the Town of Beech Mountain.)

SHOW YOUR PATRIOTIC SPIRIT. Sponsored by the Beech Mountain Chamber of Commerce, the mailbox decoration contest adds color and fun to businesses and homes each Fourth of July. From left to right, town employees Jessica Heaton, Sally Rominger, and clerk Reba Greene proudly stand by their entry. (Courtesy of Beech Mountain Chamber of Commerce.)

FUN FOR YOUNG ONES. Children enjoy Beech Mountain's free sledding hill next to the Visitor Center. With natural snow supplemented by snowmaking, the hill is open from mid-November through mid-March, weather permitting. Pictured are Annmarie (left) and Katie Simmons. (Photograph by Connie Bowen.)

THE TRAILS OF BEECH. Something for everyone is the best way to describe the 12 miles of designated hiking trails on Beech Mountain. Organized hikes sponsored by the town are led by B. J. Hughes. Pictured enjoying the outdoors are, from left to right, Gil Adams, B. J. Hughes, Gene Bowen, Bert Bittan, Marilyn Bittan, Lou Robles, and Molly Robles. (Photograph by Fred Pfohl.)

THE PONDS OF BEECH. The Beech Creek Bog was originally platted for lots, but later the Blue Ridge Land Trust purchased it. This 120-acre bog, called the Ponds of Beech, is the largest and most pristine example in the state. It is particularly significant because it was formed in a poorly drained mountain depression ages ago. It was transferred in 2002 to the state for preservation as a natural area. (Photograph by Therese Barry.)

DANCING IN THE STREET. During the summer, Beech Mountain visitors and residents can party at 5,065 feet, the altitude at the town hall parking lot, with music from the 1940s to the present. Street dances are a Southern tradition, often featuring beach music, a brand of rock and roll popularized for dancing in the coastal resorts of the Carolinas. (Courtesy of Beech Mountain Chamber of Commerce.)

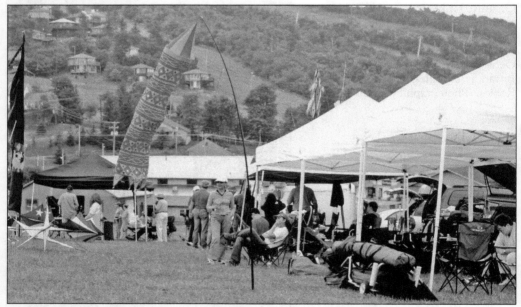

MILE-HIGH KITE FESTIVAL. Joining in high-flying fun, hundreds of kite enthusiasts participate in this one-of-a-kind event. Participants can create their own individual kites, decorate them, watch kite demonstrations, or practice kite-flying techniques. The event is held annually on Labor Day weekend. Participants receive a certificate for flying their kites above 5,289 feet. (Photograph by Ralph Miller.)

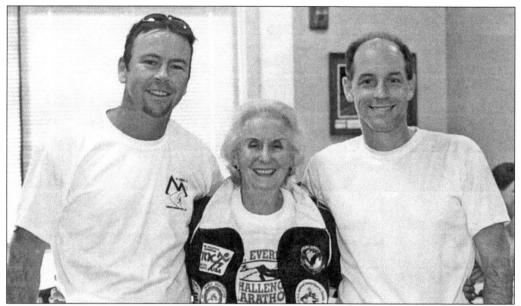

THE COOL FIVE. The 5-mile race and accompanying fun walk across the top of the mountain is open to all runners and walkers. Featured in the picture are, from left to right, Brad Mettee, codesigner of the Cool Five course; Margaret Hagerty, the oldest runner and honored guest at the inaugural race in 2008; and Rory Ellington, the mountain's foremost runner and cyclist, and the course's codesigner. (Photograph by Don Mullaney.)

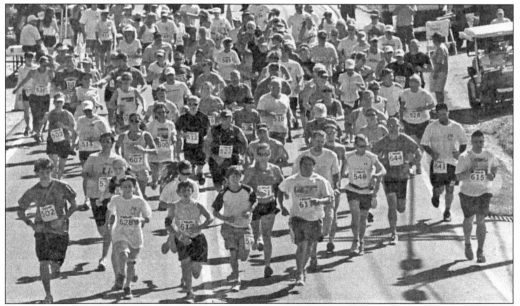

READY, SET, GO! The race begins with a head start for runners. Following about a minute behind are all the walkers. The racecourse is above 5,000 feet in elevation, with steep climbs and awesome views across the Blue Ridge. The event is held in early June, when runners from the Piedmont and elsewhere can enjoy Beech Mountain's cool summer temperatures. (Photograph by Don Mullaney.)

ALL I WANT IS . . . "Please Santa, bring one for Dad and all these for me!" Hampton Owen, son of fourth-term Mayor Rick Owen, shows Santa what he wants for Christmas. Each year Santa visits the gazebo at Fred's to hear requests from Beech Mountain's younger residents. (Photograph by Nancy Owen.)

WE ARE DIGGING HOW DEEP? A beautiful spring day greeted residents when many showed up for ground-breaking festivities at the Buckeye Recreation Center on April 17, 2004. The town's long-planned recreation center would finally become a reality. The big question is, where is Jim Brooks's shovel? (Photograph by Debbie Canady.)

RECREATION CENTER TAKES SHAPE. In 2001, the town's Long-Range Planning Committee worked with Charlotte architect Steven Overcash to design the Buckeye Recreation Center. Construction began in 2004 and was completed in 2006. The 22,550-square-foot facility includes indoor basketball, volleyball and tennis courts, and a track. There is a fitness room for adults as well as a soft playroom, plus a catering kitchen for parties. (Photograph by Rick Owen.)

HAMPTON VIEWS HIS DOMAIN. Hampton Owen, son of Beech Mountain mayor Rick Owen, enjoys playing in one of Buckeye's special features—a soft playroom. This specially designed area provides a safe and fun way for our small citizens from ages one to seven to enjoy creative play. (Photograph by Rick Owen.)

127

Visit us at
arcadiapublishing.com

···

Printed in the USA
CPSIA information can be obtained
at www.ICGtesting.com
LVHW081652091123
763115LV00084B/633